D1241862

IMAGES
of America

ORLANDO AND
ORANGE COUNTY

IMAGES
of America

ORLANDO AND ORANGE COUNTY

Wynette Edwards

ARCADIA
PUBLISHING

Published by Arcadia Publishing
Charleston SC, Chicago IL, Portsmouth NH, San Francisco CA

Printed in the United States of America

Library of Congress Catalog Card Number: 2001092297

For all general information contact Arcadia Publishing at:
Telephone 843-853-2070
Fax 843-853-0044
E-Mail sales@arcadiapublishing.com
For customer service and orders:
Toll-Free 1-888-313-2665

Visit us on the Internet at www.arcadiapublishing.com

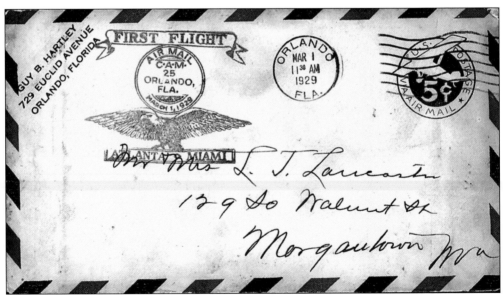

This letter was on the first flight from Orlando when airmail service began in Orlando on March 1, 1929. The special cancellation on the left was typical of the "first day covers." Airmail was much more expensive than overland mail, which could be sent for 2¢ at the time. Orlando was part of the Miami to Atlanta route.

CONTENTS

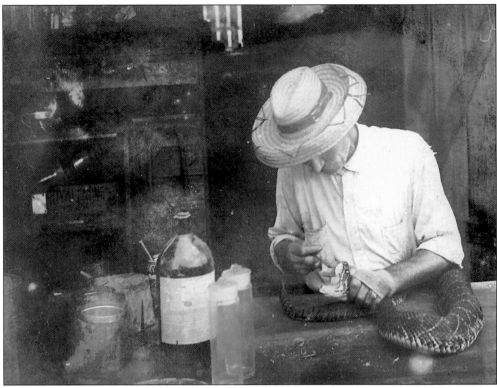

This man is milking a rattlesnake by gripping the snake behind the head so that it will open its mouth. The fangs come forward when the mouth opens. Although a diamondback rattlesnake can yield over 1,000 milligrams of venom, this man is only using a tablespoon to catch the venom.

ACKNOWLEDGMENTS

This book was made possible by the Historical Society of Central Florida at the Orange County Regional History Center with its extensive collection of photographs of Orlando and Orange County from days gone by. To the Historical Society and to the employees of the History Center who took the time to help me find the photographs and information to go with them, especially Cynthia Cardona, Joe Gillette, Tana Porter, Vince Herrera, and Ted Saunders, I am very grateful. They were a great group of people to work with.

I am also indebted to Bob Atac, Rachel Haymes, Bob and Kim Showalter, Kevin McNameria, Bryant Bouslog, and Julian Zenitz for their help with the aviation history. The Showalter scrapbook that was compiled by Buck Rogers was also a good resource in compiling this book.

Several of the images found in the second chapter are in the archives of the Historical Society of Central Florida courtesy of the Florida State Archives and are so marked.

INTRODUCTION

One of my early memories of Florida is of my mother driving on a sandy road, going down a hill and over a wooden bridge that had no side rails. She made it feel like we were riding a roller coaster. That was my version of Disney's Space Mountain, which was one of my children's early memories. This book focuses on the region as it was before Walt Disney made his mark on Central Florida. It is dedicated to the newest member of my family and an Orlando native, Samantha Ross.

It is always interesting to take a look at the beginnings of settlement in an area. Why did the people choose to live here? What did they find when they first arrived? What made the pioneers choose one location over another just a few miles away? And how did they "civilize" the frontier? Then, what drew the next wave of people? The first chapter of this look-back at Orange County answers some of these questions through photographs that were available in the Orange County Regional History Center. Some early towns are not represented, such as Eatonville, Gotha, and Winter Garden, because photographs of these towns before 1970 are not in those archives.

The first major draw for Orange County is still its most important industry. Tourists found Central Florida very early and went to great lengths to travel to the area for the fresh air and exotic fauna. In the early years, January through March was the tourist season. But when visitors began driving to Orange County, that season expanded to include summers when schoolchildren were on vacation. Now, tourism is a year-round business. Visitors still travel to Central Florida for the climate but instead of months they now stay a few days or a couple of weeks. This book looks at the time when visitors weren't in such a hurry and spent more time in the area once they arrived. As you browse, look at the places that the earlier tourists stayed and the pleasures they enjoyed.

The second great industry of the area is, and has long been, the citrus industry. Maybe you have never thought of what it took to get that orange from the grove to your table. There are still a few people around who remember when an orange in the Christmas stocking was a real treat. As you section the next orange that you eat, think of all the steps it takes to get that orange to you and what hardships early growers overcame to make the industry a viable one.

In addition to welcoming tourists, Orange County developers and promoters targeted their pitch to potential new residents. Advertising was just coming of age in the United States as the county was being settled, and early promoters used every type of advertising to tout the best features of the area. Never was a frontier so well advertised as Florida. Land was cheap but people were scarce, and those who were here made sure that those who were not were told about what they were missing.

Orange County grew up with the airplane. The climate made this a natural area to fly in year-round and that helped to attract those who were passionate about this new mode of transportation. They, in turn, found ways to enjoy their new interest by holding air meets and races for others who wanted to spend some time in the sun. When the Army, Navy, and Air Force were looking for places to site their facilities, Orange County was again a natural, and local officials made sure that this fact was known in the right quarters.

So, draw up a rocking chair, turn on the overhead fan, make a glass of tea, and settle into a look at pictures of Orlando and Orange County from its beginning until the establishment of Disney changed the area forever.

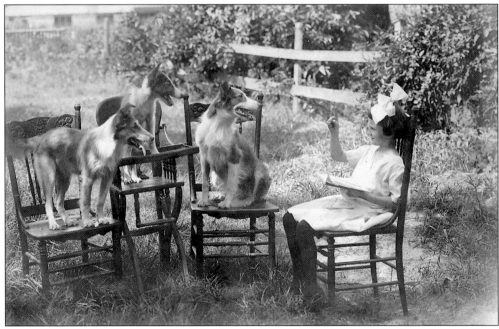

Playing school was a favorite pastime of little girls in days gone by, and when other children were not available, dolls or pets substituted for students. These dogs are very attentive to Laura Robinson's lesson.

One

EARLY DAYS

The Seminole War of 1836 prompted the building of several forts in what is now Orange County. After the war, these forts became the nuclei of several towns in the county. The best known were Forts Gatlin, Reed, Christmas, and Maitland.

Aaron Jernigan, an early settler, opened the first post office near Lake Holden and Fort Gatlin. He named the town Jernigan, but it was changed to Orlando in 1857. When the town was formally platted, all the native pine trees were removed. Orlando was the official county seat by 1856. As an incentive to make Orlando the county seat, Jacob Summerlin gave the county $10,000 to build the first courthouse as long as the county built it there.

Winter Park backers wrote that their city was designed to attract people of "intelligence, culture and wealth." Most of the other towns in Orange County were formed as marketing centers for the farmers in their areas. The settlements by the lakes were also magnets for winter tourists. In many cases, hotels were some of the first buildings in town.

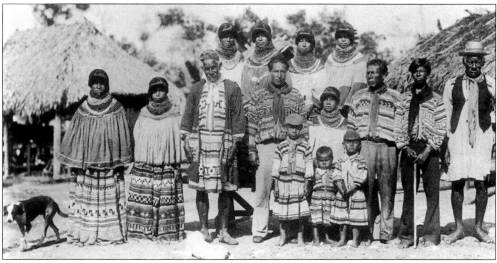

The first settlements in the region were established as early as 2000 BCE to 1000 BCE. The Seminole Indians, inhabitants of the area in the 1800s, were known to be fierce but the superior firepower of the European settlers defeated them. In 1842 an agreement was reached whereby those 300 or so Indians who had not been captured and sent west were allowed to remain in the southwest section of the peninsula.

HOMESTEAD.

Receiver's Office, *Gainesville, Flea*
September 20th, 1875.

RECEIVED of *Cassius A. Boone*, the sum
of *Fourteen* dollars ———— cents;

being the amount of fee and compensation of Register and Receiver for the
entry of *SE¼ SE¼ Sec 36 T 21 R 29 + NE¼ of NE¼ Sec 1 T 22 R 29 and W½ SW¼ of Sec 31. T. 21. R 30 ε* in
Township of *Range* under

the acts of Congress approved *May 20, 1862*, and *March 21, 1864*, entitled
An act to secure homesteads to actual settlers on the public domain."

S. F. Halliday
Receiver.

$14

NOTE.—It is required of the homestead settler that he shall reside upon and cultivate the land embraced in his homestead entry for a period of five years from the time of filing the affidavit, being also the date of entry. An abandonment of the land for more than six months works a forfeiture of the claim. Further, within two years from the expiration of the said five years, he must file proof of his actual settlement and cultivation, failing to do which, his entry will be cancelled. If the settler does not wish to remain five years on his tract, he can, at any time after six months, pay for it with cash or land warrants, upon making proof of settlement and cultivation from date of filing affidavit to the time of payment.

Permanent settlers in the Orange County area first came under the Armed Occupation Act of 1842, which offered 160 acres to those who agreed to live in the area and maintain their own defense. Aaron and Isaac Jernigan and Elam Lee were among those who settled under this act. The second wave of settlers arrived after the Civil War and worked for land under the Homestead Act of 1862.

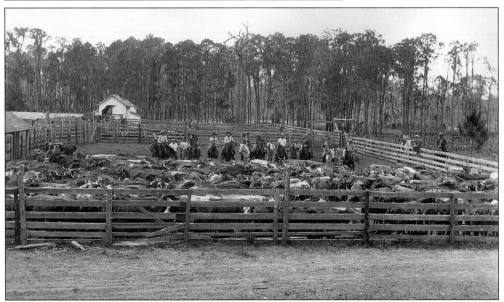

Pioneers such as Aaron Jernigan and Andrew Barber brought cattle to the territory. These cattle soon ranged over most of Central Florida. During the Civil War, cattle as well as cultivated crops and wildlife were sold to the Confederate Army, and later to the Union Army, to feed soldiers. Early Orlando was a cow town with no more than a couple of stores, a bar, a hotel, and a courthouse.

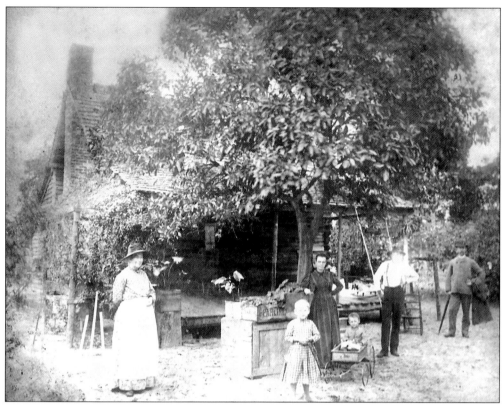

The extended Mizell family, thought to be among the first white settlers in the area, settled in what is now Winter Park. David William and his wife, Angeline Mizell, set up housekeeping in the area that is now the Harry P. Leu Gardens but was then a beautiful, wild area.

David William Mizell was named the sheriff of Orange County in 1868. He was killed in action in 1870 at Bull Creek while he was on his way to collect the tax on cattle from Moses E. Barber. His 32-year-old widow was left with seven young children to raise.

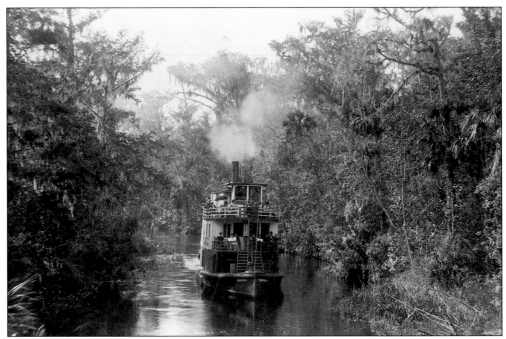

Before the railroads were built in Orange County, people and goods traveled inland by foot, horse or mule, cart or buggy, and steamship. The fruits of the new citrus industry were shipped by steamship, and Central Florida was soon being promoted as a place where people could escape harsh winter climates. Visitors usually arrived by steamship to spend their winters in the balmy climate.

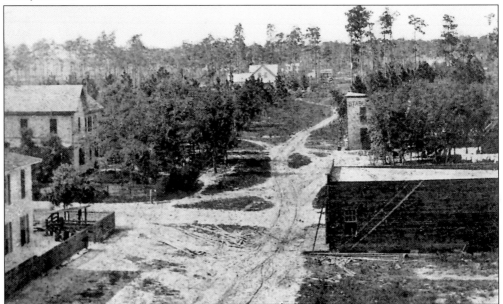

This 1879 photograph shows Orlando from the vantage point of the roof of the Ogilvie Hardware building at Orange and Pine, looking north. The road meanders and goes around stumps. There were plenty of empty pine forests around the settlement where one could ride all day without seeing another person. This is thought to be the oldest photograph of Orlando.

Another early view of Orlando shows the town well, which was noted for its sweet, pure water. The area was already being promoted as a very healthful region. The photographer who took this view was standing beside the new frame courthouse, which was completed in 1875. The first log courthouse had burned in 1868.

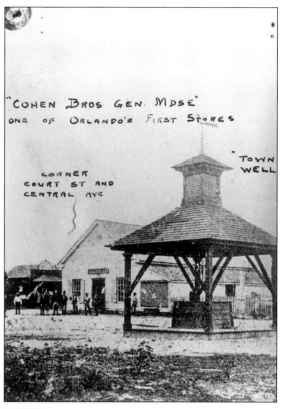

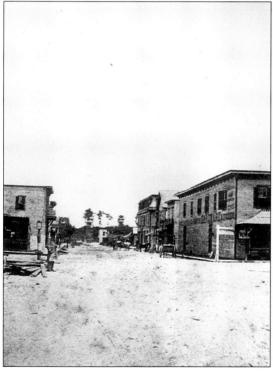

Here is yet another 1879 view, this one looking north from Church Street. By 1880, Orlando's population was between 100 and 200 and the commercial district was said to include three stores, one hotel, one blacksmith and wagon shop, a livery stable, and a saloon. Six years later, there were 4,500 people who supported 50 stores, seven churches, five hotels, three bakeries, two weekly papers, an ice factory, and a livery stable.

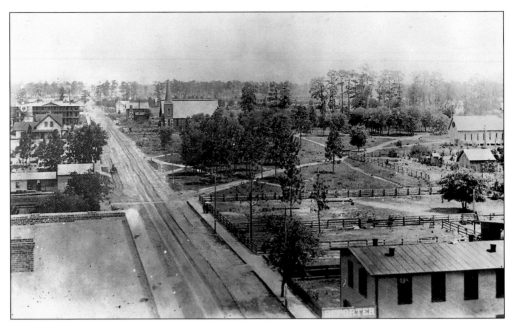

What a difference ten years made in Orlando! This view was taken from the roof of the San Juan Hotel around 1888 looking north along Orange Avenue. The road is straight and boardwalks line the commercial portion of the road. The Arcade Hotel with porches around the building on each floor is on the left and St. James Catholic Church is across the street. A short walk away is St. Luke's Episcopal Church on the right.

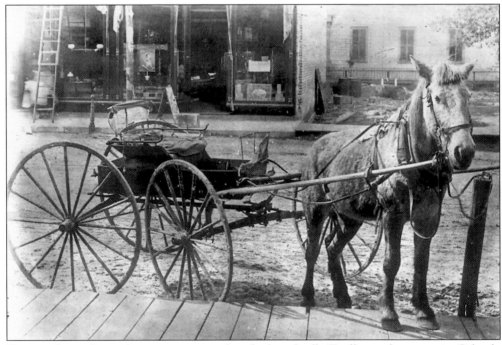

Here is a horse that isn't quite accustomed to the boardwalk. Traffic on the streets in Orlando kept the thoroughfares well rutted so that they were nearly impassable. Winds pushed the loose sand into the nearby houses and shops, making living near a road uncomfortable.

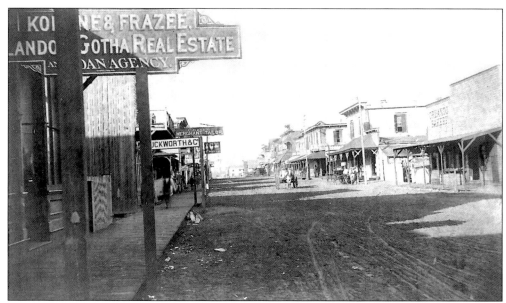

Here is a view of Church Street in 1885. The Koehne & Frazee, Orlando & Gotha Real Estate sign is partially hidden by a post. Seven-foot wooden sidewalks were constructed in 1883 to help keep the sand and dust out of the downtown buildings.

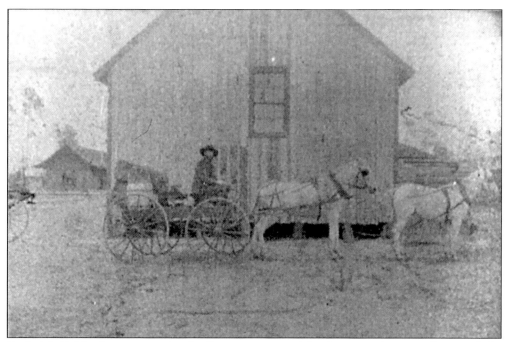

Frederick G. May began operating the first passenger and freight service between Conway, Lake Underhill, and Orlando in 1884. These horses are hitched one in front of the other because the load May was carrying was too heavy for just one horse, his usual hitch. May also advertised that he would deliver ice in 50-pound lumps and do plowing. Fares from Conway to Orlando were 25¢ one way and 40¢ for a round trip.

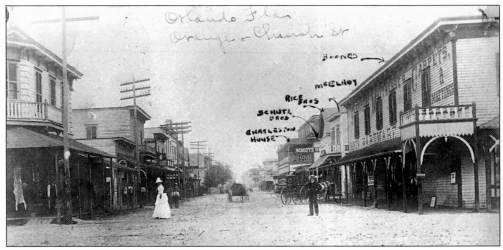

Look north on Orange from the corner of Orange and Church in 1884 to see Boones, McElroy, Rice Bros., Schultz Bros., and Charleston House on the right side of the street. The businesses on the left side are not identified.

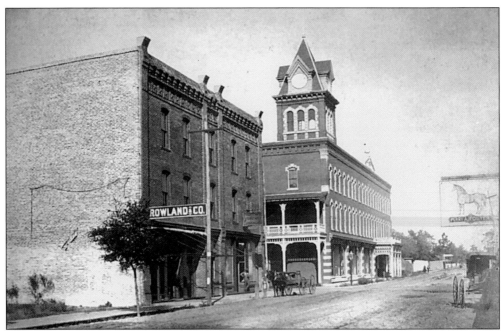

The three-story building with the tower is the San Juan Hotel, which was built in 1887 by Henry S. Kedney, a local orange grower. When it was built, the hotel was the largest in Florida. The San Juan sent notices of their arrivals to the morning paper so that everyone would know who was in town for the season.

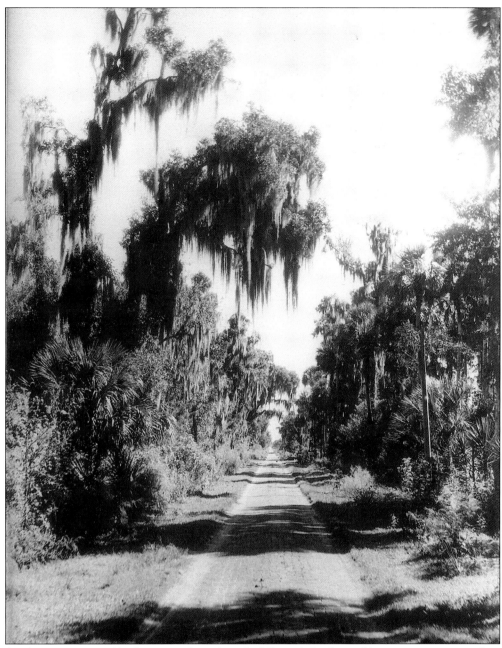

As shown on page 11, the original sand roads followed the line of least resistance, avoiding stumps and scrub. In 1884 red clay was discovered near Bartow Junction in Polk County while the South Florida Railroad was laying tracks. A later clay find lay between Orlando and Ocoee. This particular clay hardened when it was spread over the sand and exposed to air. This paving material was such an improvement over the sand roads that paving roads became a priority of the cities. Orange County adopted a program of road building in 1898, and individuals even contributed to the cause. Builders also experimented with other materials such as shells for road building. As you can see in the above photograph of a county road by the time the program of road building began, straight paths prevailed over winding ones for the roads.

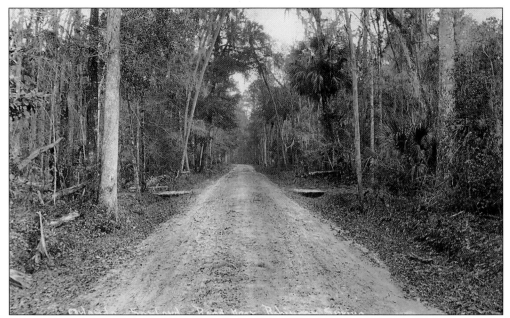

The road cut between Orlando and Sanford was still a sand-based one when this picture was taken. From the late 1890s until World War I, the county sometimes used pine straw to surface roads. By 1905, Orange County had 100 miles of clay-surfaced roads and boasted of having the best roads in the state.

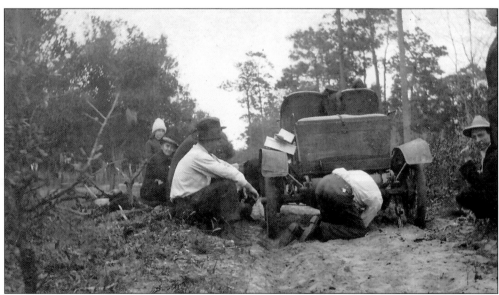

Sand didn't keep people from driving their new automobiles on the roads. If a break down occurred, the passengers simply piled out and watched as the owner assessed the problem and tried to repair the car. These people don't even seem unhappy about it. In those days, it was just part of the driving adventure!

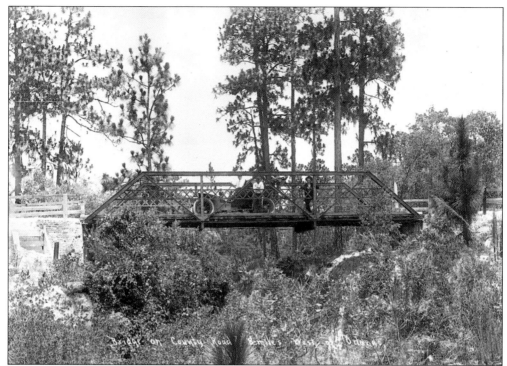

Here is an image taken by T.P. Robinson, who photographed much in Orange County in the early 1900s. This bridge has an iron frame with wooden crossties for the road. This was a substantial bridge for the time since many early bridges had no side rails.

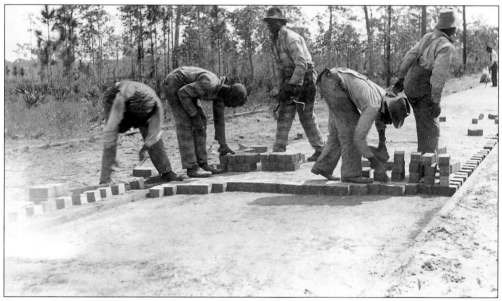

Convicts were leased from the State for roadwork, a standard practice at the time. That was how the State paid for the housing and caring for prisoners. In addition to road building, convicts were used to construct railroads and they worked in turpentine and lumber camps. Their treatment was up to the person hiring them for there was no supervision by the State.

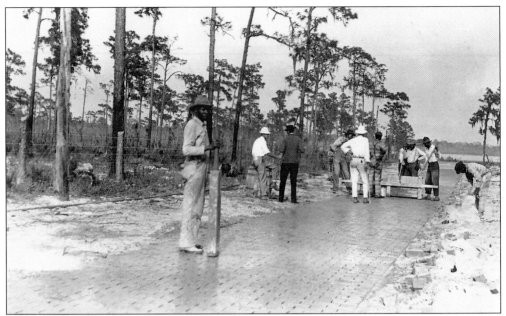

Automobiles came to Orange County in 1903, making better roads an ever-increasing concern. By 1910 it was decided that it was a waste of money to continue constructing clay roads. A bond issue to provide for hard-surfaced roads was passed in November 1913, and road building was to be completed by 1916. Brick roads were to be built nine feet wide with three-foot shoulders. An earlier brick road between Orlando and Winter Park was constructed in 1896.

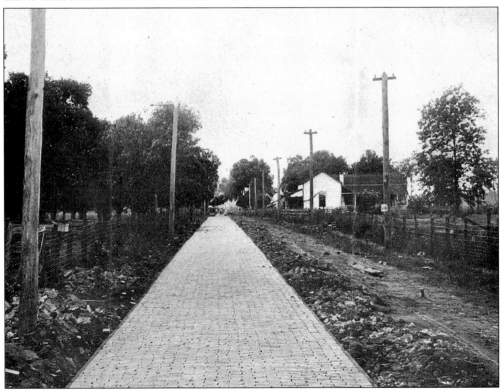

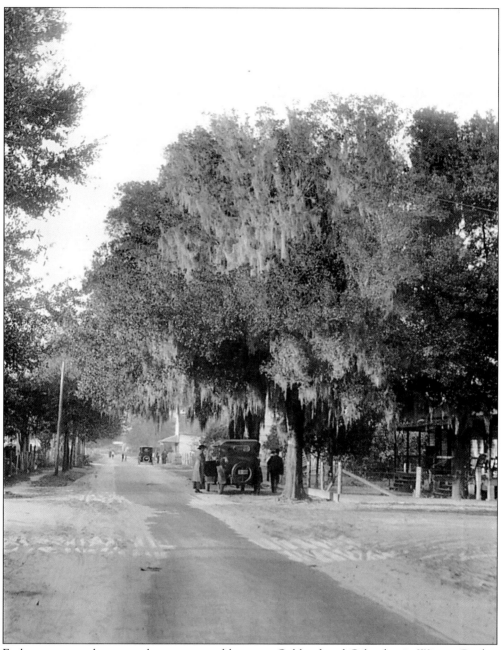

Early county roads were to be constructed between Oakland and Orlando via Winter Garden and Ocoee; from Orlando to Zellwood via Apopka and Lockhart; from the Osceola County line to the Seminole County line, via Taft, Pine Castle, Orlando, Winter Park, and Maitland; and from Orlando east via Conway, at least five miles; as well as from Orlando east on Fort Christmas roads for at least three miles. Shown here is a completed brick road in Pine Castle in 1920. Notice how the sand has silted over the edges. These nine-foot roads were too narrow for two cars to pass, and when they met, it was necessary for one to pull over on the shoulder for the other one go by. That worked well when the shoulders were hard packed, but if the shoulder was sandy, the driver who pulled over might need help getting back on the road.

Loring A. Chase and O.E. Chapman founded Winter Park in 1881, but the city was not incorporated until 1887. The city, on the crest of the watershed between the Gulf of Mexico and the Atlantic Ocean, proved to be a healthful location. Recognizing the value of the location and the beauty of the Southern pines, Chase and Chapman bought the land bordering Lakes Virginia, Osceola, and Maitland for their town. This image was taken in 1883 when there were only a few buildings.

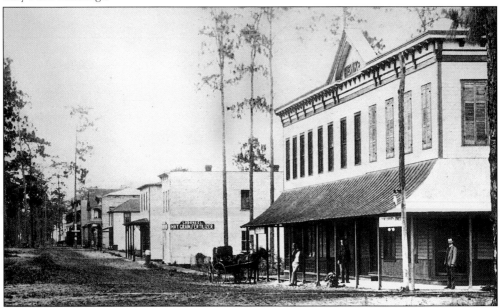

Look along Park Avenue a few years later. By 1887 the town had three good hotels, three churches, Rollins College, about 100 cottages, and a flourishing business district with an express and telegraph office, several stores, and two steam sawmills. The depot for the South Florida Railroad was the first building in town and made access from points north easy for winter visitors.

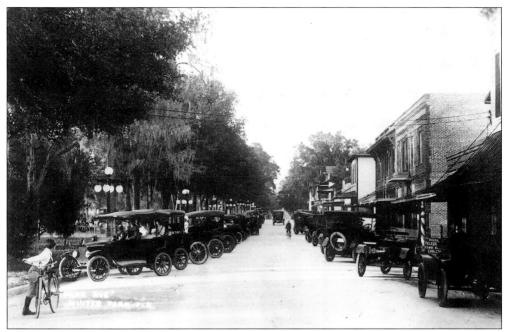

By 1887 Winter Park's reputation as a good winter resort was firmly established. Now step a few paces forward and to the right for a view of Park Avenue in the 1920s. If you can see through the "parking lot," you will notice that the commercial section is filling in and business is brisk.

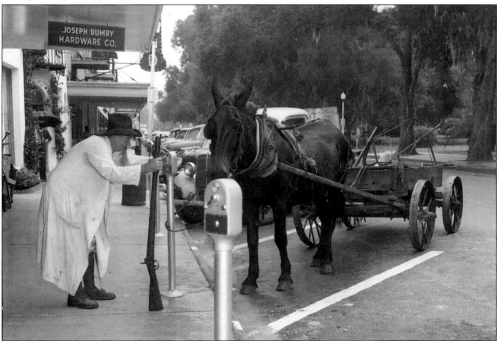

There were only 15 automobiles in Winter Park in 1911. Thirty-six years later, the city was so congested with traffic that 150 parking meters, with rates of 1¢ for 12 minutes and 5¢ for an hour, had been installed. This gentleman in from the country is making sure that his horse and wagon are legal. That rifle must have been quite a shock to the winter visitors, though.

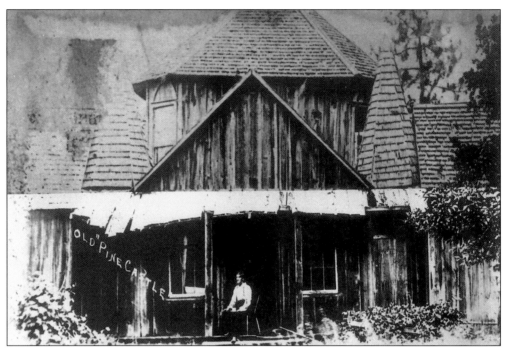

Seated in the doorway of this unique house is its builder Will Wallace Harney, who moved to Orange County for his wife's health. After her death in 1870, he continued his journalism career by writing about the beauty of Central Florida and the advantages of living in the area. The town of Pine Castle was named for Harney's house.

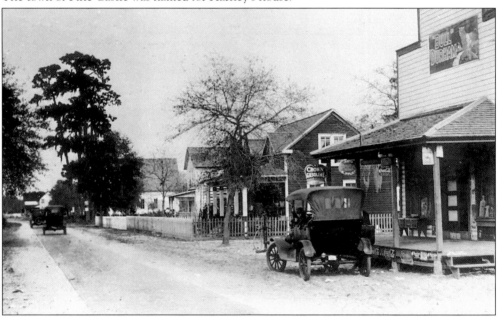

The Dixie Highway, which opened in 1925, ran from the Canadian border in Michigan through Pine Castle and on to Miami. If you look closely, you can see that the highway was part of the original brick road system of nine-foot roadways. The mercantile store on the right probably also housed the Pine Castle Post Office.

The handsome Bosse family is shown here seated on the steps of the Formosa Post Office. The town is gone now, but the beginning of today's Formosa Avenue in the College Park area of Orlando is its former location.

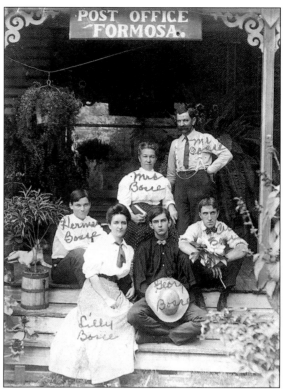

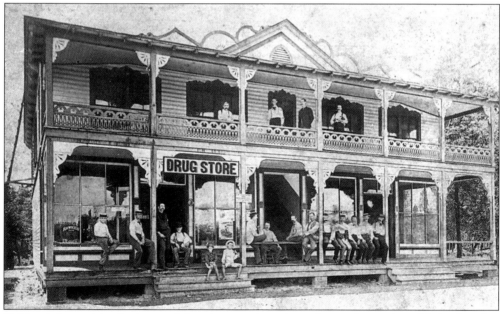

Oakland, located in the heart of the citrus section along the southern edge of Lake Apopka, once had two railroads running through it. A drug store as large as this indicated that the town had grown rapidly by the late 1800s. As so often happened, fire destroyed the town and caused the failure of the railroads there. Yet the town survived as the center of a fertile farming community in Orange County.

Nettie Van Dorn Phillips lived in this historic house in Chuluota. Oranges and vegetables were the leading industries of Chuluota just as they were in most small towns in Orange County.

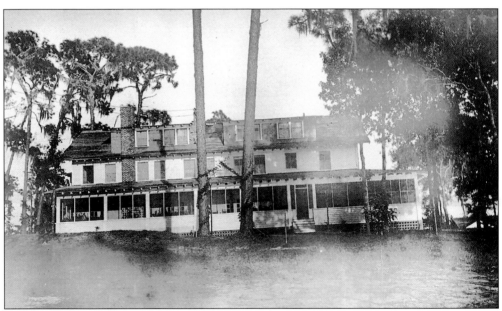

Windermere was first laid out in 1887, but most of the settlers left after the freeze of 1894–1895. Development began again in 1910, and around 1917 the Thompsons from Ohio built the Pine Tree Inn on a bluff overlooking Lake Butler. Many of their guests, charmed by the area, later built houses in Windermere.

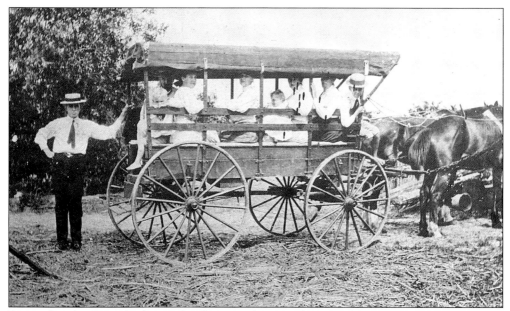

Pictured is the Hotz-Anderson family using the Apopka school bus to go to the Methodist Church in that community. Piedmont students were transported to school on this bus from 1903 to 1912 after the number of students dropped too low to employ a teacher in Piedmont. Students often entertained themselves on the long ride by getting out to chase pigs, cows, or alligators along the way.

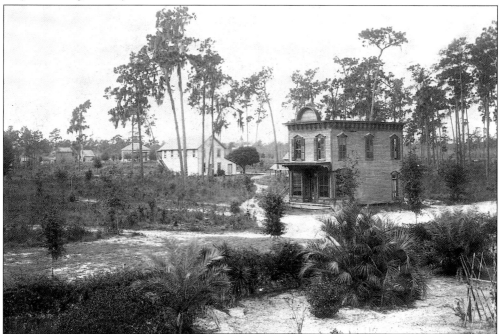

Early settlers were attracted to Ocoee because of its high location and suitability to agriculture, a prime industry there since the 1860s. The town was first called Starke Lake, and it was in Starke Lake that John Hughey opened the first general store in 1880. Ocoee was incorporated in 1923.

Ocoee was settled in 1868, and its population by 1880 was 75 people. The first resident was probably a Dr. Starke, but Ocoee was also the home of Capt. B.M. Sims, known as the father of orange growing because he was the first in the country to operate a commercial citrus nursery. The community's fire and police departments were organized in 1923.

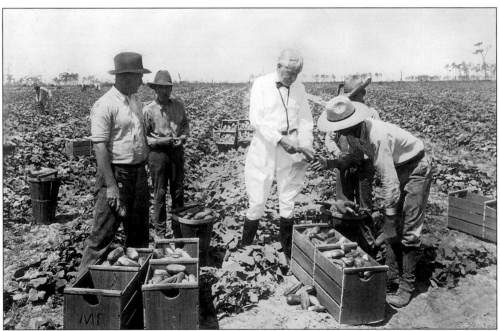

Traditionally, Ocoee has been noted for its production of citrus and vegetables such as lettuce, peppers, beans, eggplants, tomatoes, and cucumbers. Produce was first shipped by boat through the lakes and up the St. Johns River to the Atlantic seaboard. Here, men inspect a cucumber harvest.

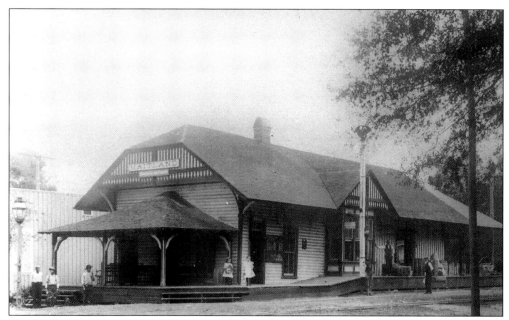

Maitland was a thriving community even before the railroad came to town. Fort Maitland was established in 1838, but the area had previously been known as Lake Fumecheliga. Before this depot was built about 1885, the railroad station had been on the ground floor of Packwood Hall, the town hall and community center.

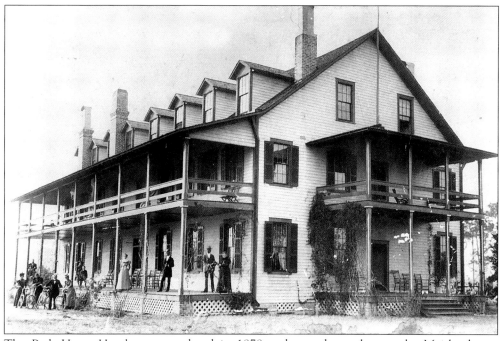

The Park House-Hotel was completed in 1878 and served travelers to the Maitland area between Lake Catherine and Park Lake. Before it burned in 1916, the structure was also called the Maitland Inn. The building design was a traditional one for the Orange County area with plenty of porches for the residents.

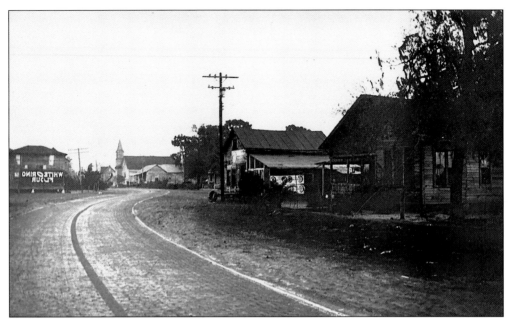

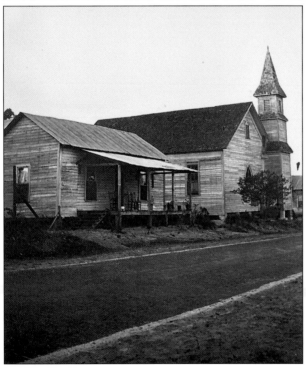

Apopka, in the northwest section of Orange County, is on an extensive plateau 45 feet higher than Orlando to the south and east and has good drainage and good soil for agribusiness. Apopka became known as the foliage capital of the world as indoor plants as well as citrus and truck farm vegetables were grown there. Early in the 20th century, lumber companies built "quarters" for their African-American workers. Churches, stores, and schools soon followed. The photograph (printed in reverse) above shows some of this area with a church in the background. The image to the left shows the same church; both were taken in the early 1940s. Notice also that the brick road now has a stripe down the center.

Two

CITRUS GOLD RUSH

The first citrus to be shipped commercially out of Orange County was loaded into crates, hauled in ox-drawn wagons to Mellonville (now part of Sanford), and loaded onto steamboats to travel down the St. Johns River to Jacksonville and then on to Charleston, South Carolina. From there it was usually exported to Europe. The shipping containers were wooden barrels and fruit was wrapped in Spanish moss. There was a high degree of spoilage in these early years.

When the railroad connected Orange County to the rest of the country, growing and shipping citrus began to be profitable, for the fruit could be shipped more efficiently with much less spoilage. By now the primary markets were in the Northern states.

Many of the early growers had been lured to the area by reading how easily citrus could be grown. Land was cheap and people came from all over to cash in on the citrus gold rush. Some thought that all they had to do was plant the trees, sit back in leisure, and wait for the oranges to come!

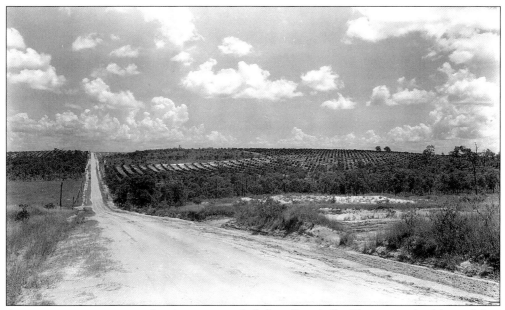

A citrus grove appears in the distance on slightly rolling hills. Trees were healthier if they were situated on the south or southeast side of a body of water on well-drained soil. One of the earliest groves recorded in Orange County was the Roper Grove.

Many settlers who moved to Orange County found wild orange trees. Almost all of the early settlers planted at least a few citrus trees and several had sizable groves by the mid-1870s. In the early years some growers were "Mom and Pop" operations, gathering small quantities of fruit to be shipped to relatives or friends who sold the fruit for them.

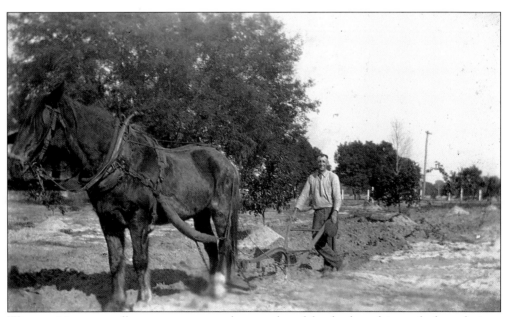

Winter visitors as well as permanent settlers purchased land, cleared it, and planted citrus groves. Citrus trees are planted primarily in the winter months when the trees are dormant. Here, the grove of John J. Anderson of Piedmont is being plowed for more trees. Anderson lost his groves in the great freeze of 1894–1895 and never replanted citrus.

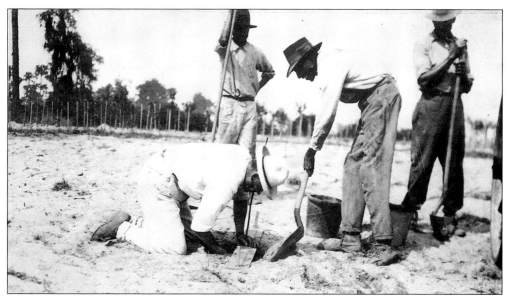

In the mid-1880s, books that gave instructions related to the planting and care of citrus were available and contained very specific guidelines on preparing soil, preparing the roots to be planted, and layering sand and water when setting new plants in the ground. Year-by-year guidelines were provided for the first five vulnerable years.

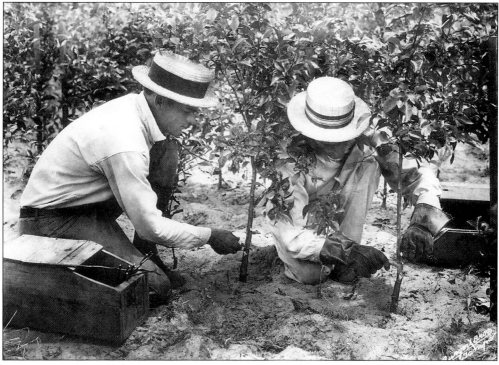

Two men perform the budding step in growing trees in the early 1920s. It will be another year before these trees are ready to be planted in a grove. Most citrus trees are grown from budded trees rather than from seedlings because budded trees take less time to mature. Most Florida orange trees have orange stock budded on rough lemon roots.

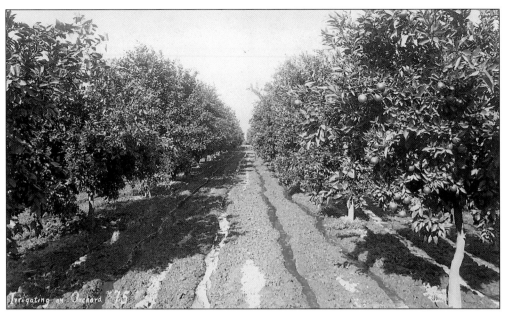

Young trees need plenty of water, especially in the spring. Unless citrus trees have plenty of water they cannot make the best use of the fertilizers that are applied and may shed their leaves, have inadequate blooms and serious deterioration, or dropping of fruit.

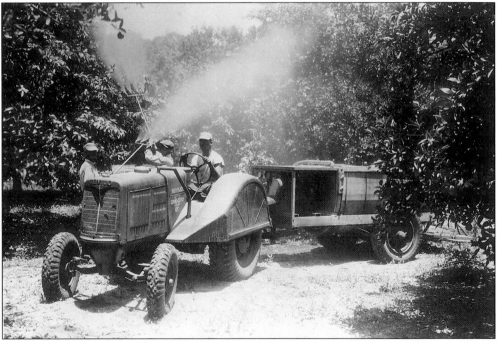

Spraying to keep the pests away is begun in the fifth year when the trees begin to bear good fruit. Spraying is also a way of applying minor fertilizer elements, especially zinc and copper, because these elements move into the trees more easily through the leaves than the roots. Spraying to add minerals is applied to new and older trees.

Although only identified as the Bradley grove, this image may be an early grove because pines and oranges are growing together and the trees are widely spaced. Can you see the water in the background? Because water cools more slowly than air, it helps keep the area warmer, thus offering some protection to the fruit in cold weather.

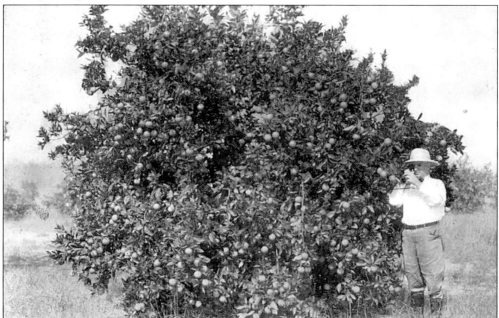

This very serious man examines oranges with a microscope in the Avalon Orange Groves near Winter Garden. He is looking for pest damage to the fruit. In 1929 the Mediterranean fruit fly was a serious concern to Orange County growers. No fruit could be packed in a quarantined area until the grove had been inspected and found free of the fly.

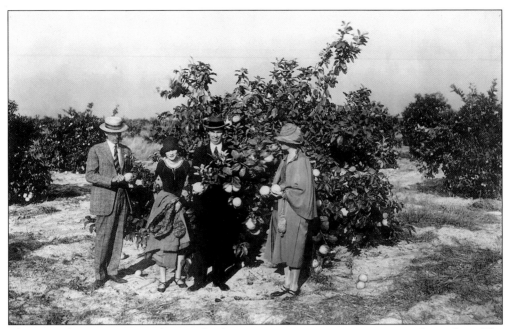

These people may represent absentee landowners in town to examine a grove of grapefruit. The man on the right is pleased with the quantity and size of the fruit, while the man on the left will be testing the fruit before he commits. The first grapefruit shipments from Orange County were made in the early 1880s.

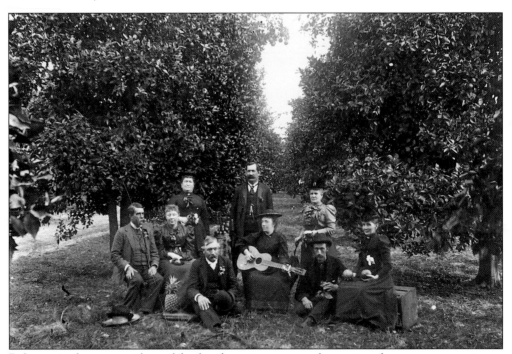

Relaxing in the grove with good food and music was a popular pastime for grove owners, just as the Sunday afternoon drive became entertainment during the 1940s and 1950s. This grove was situated near Pine Castle.

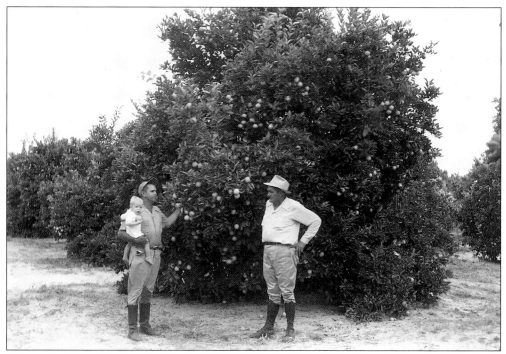

The man on the left took his child to work when it was time to inspect this fruit. Here, he decides what grade this fruit will be marketed under. The color, the presence of scale or pest damage, and the ripeness are assessed; the better the condition of the fruit, the better grade it will be assigned.

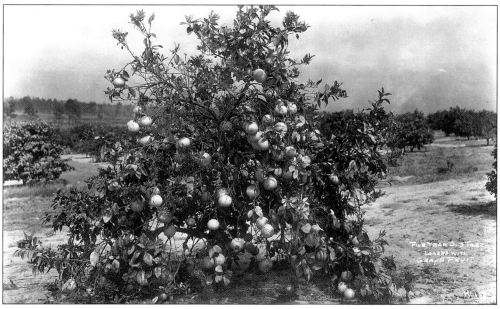

This young tree is fully laden with fruit, and the low branches are nature's way of protecting the trunk against damaging sunscalding. In the early 1880s much of the crop was sold "on the tree" and buyers hired the pickers and packers themselves. By the mid-1880s a large portion of the crop was being gathered by the grovemen and shipped by rail.

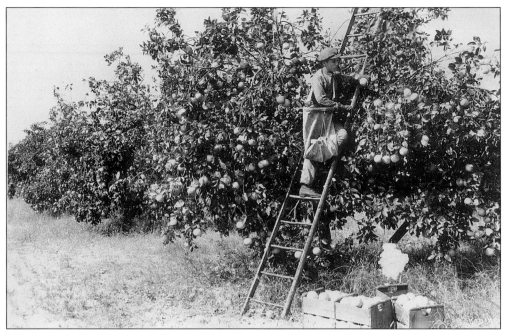

Before 1900 fruit was simply pulled from the branches, sometimes causing part of the rind to be left behind. This was called "plugging" and wasn't good for the fruit or the tree. From 1900 to 1940 fruit was clipped from the tree. During the labor shortages of World War II, pickers were taught to twist the fruit at an angle to the twig and then jerk the fruit downward to avoid "plugging."

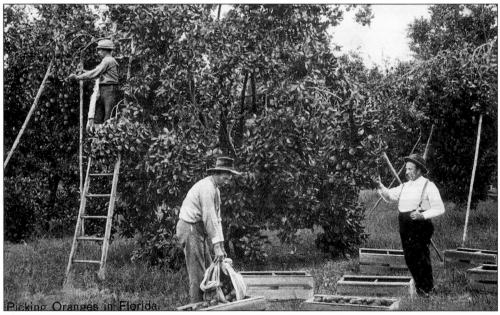

These men work with more mature trees than the man in the photograph at the top of this page. Citrus manuals stressed that each picker should wear gloves to avoid fingernail scratches on the fruit and that sacks should be emptied into field boxes with the greatest possible care to avoid bruising the fruit. (Florida State Archives.)

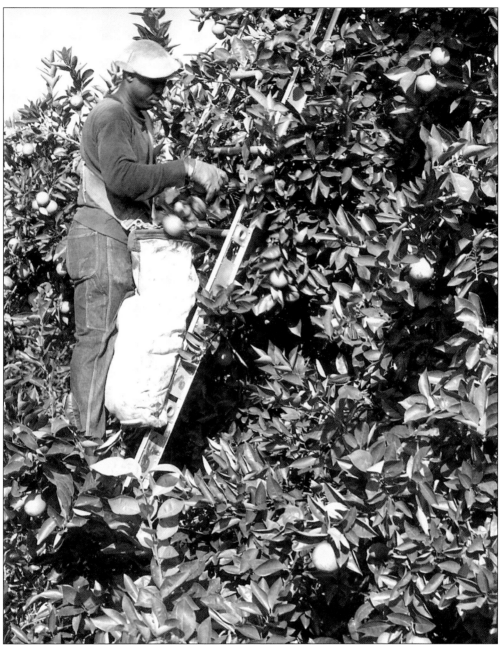

Every picker carries a canvas bag called an Allen Bag that can be opened from the bottom as well as the top. When the canvas bag is filled, it is emptied from the bottom into field boxes. The Allen Bag will hold 45 to 50 pounds of fruit when full, and each field box holds 90 pounds of fruit. Although many methods have been tried, ladders are still the best way to pick citrus fruit. Ladders must be long enough to reach the top of a tree, some of which have grown to 30 or 40 feet. With current pruning practices the height of the trees is being kept at a lower level. A well-structured tree has limbs that are spread apart and make picking easier. On a good tree, a picker can get all the fruit with seven sets of his ladder. The average yield is 1,500 oranges per tree per year. (Florida State Archives.)

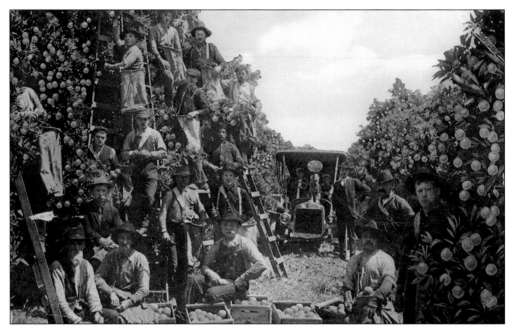

This photograph has been staged for a postcard look at a Florida orange grove. None of the men are wearing gloves and all of their Allen Bags are empty except for the man kneeling on the right. He may be the only picker in the crowd! (Florida State Archives.)

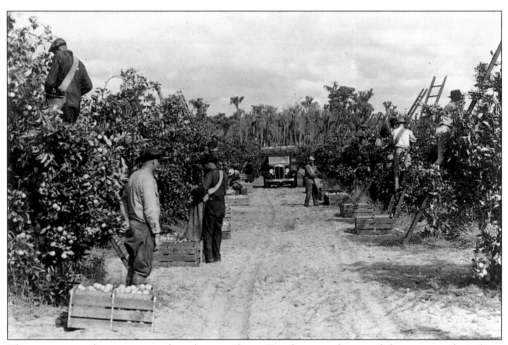

This appears to be a picture of working pickers. Trucks were first used for moving fruit from the groves to the rail sidings in 1918. There are some records of railroad track being laid right through the groves to avoid hauling the fruit from the grove to a distant rail siding.

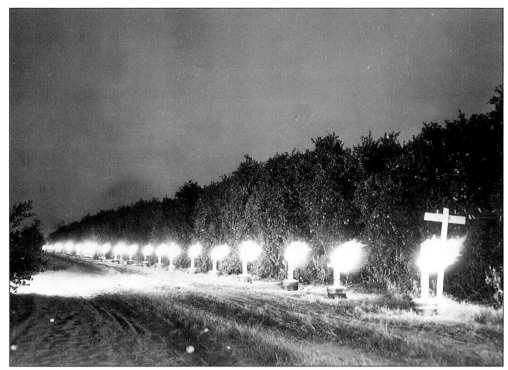

Until the freeze of 1894–1895 growers relied solely on a favorable location to protect their groves from cold. By 1899 some groves were heated during freezing weather. There has been much trial and error in heating, but heaters—at the rate of 100 to the acre—proved to be the most efficient. (Florida State Archives.)

While more progressive growers chose to heat the air during cold weather, many more were in favor of covering trees with tents or wooden barriers, such as these, in 1905. Later these barriers or sheds were more often used where there were only a few trees or important trees for budding purposes were involved. (Florida State Archives.)

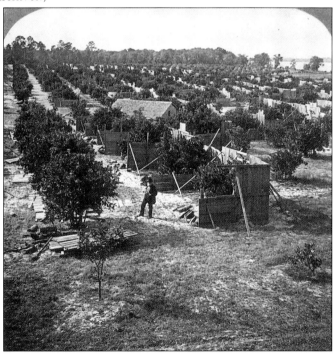

Orange County growers planted a million new orange trees between 1873 and 1876. Then came the freeze of 1895. The following description of the Great Freeze was written from remembrances in the 1930s.

Christmas day 1894 was one of the beautiful sunshiny days, with temperature in the eighties, flowers blooming, birds singing, all nature in a holiday mood. The following Sunday afternoon a terrific rainstorm came up with a howling wind out of the northwest. In the morning pumps were frozen, water pipes began to burst all over town. In 36 hours the blizzard had passed, the sun asserted itself and there followed ideal days. Sap started in the trees, leaves came out, orange trees blossomed, all took new courage and then Feb. 7 the blizzard came back. Desolation, despair, despondency, depression. Those who could go, went, those who could not, stayed. All orange trees, with some isolated exceptions, froze to the ground.

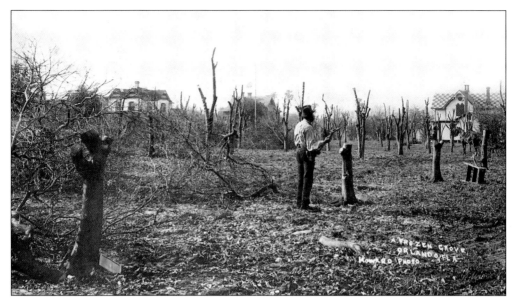

Here, a grower who decided to stay in Orange County after the great freeze cuts his trees back so that they could begin to grow again. This freeze threw the local economy into a tailspin. More people moved out of Orange County than moved in; banks closed, citrus packing plants closed, and even the water works closed for a few years. It wasn't until 1910 that production levels rose to those of 1894.

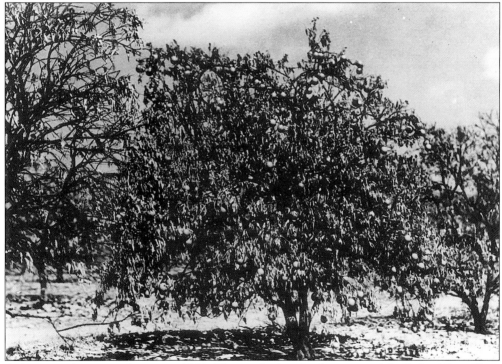

A disastrous freeze struck again in 1934. This resulted in the formation of the Federal State Frost Warning Service to forewarn growers of bad weather. Compare the damage in 1940 shown in the above photograph with that of 1895 shown in the photograph at the top of the page.

43

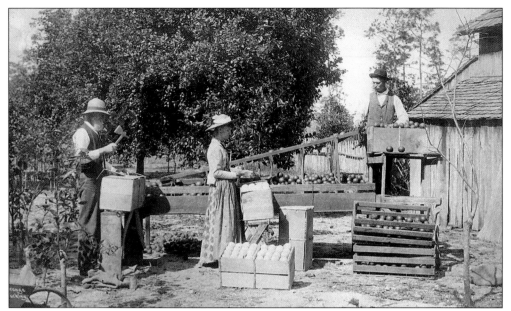

These people get the citrus ready for shipment. Before packinghouses were organized in the early 1900s this function was performed right in the groves. The man to the left makes divided boxes as needed; here, he nails the top on the box. The man on the right sends the fruit down a sorting board, which directed the fruit into bins by size. The woman puts the fruit into the boxes. (Florida State Archives.)

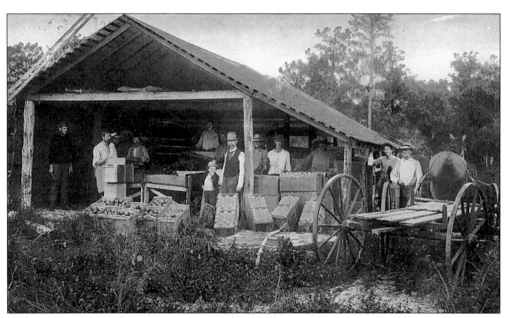

Packers moved from the grove to tents to sheds before moving into packinghouses. Here, they take the fruit from the field boxes and pack them in divided boxes, which distribute the weight of the fruit and help keep it from shifting during shipment.

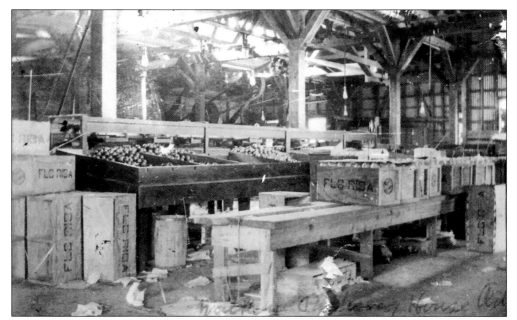

There were at least four packinghouses in the Apopka area before the freeze of 1894–1895.
There were located in Merrimack, Plymouth, Clay Springs, and near Clarcona. Between 1885
and 1895 packers began to grade and wash fruit before packing. This photo shows the Walker
Packing House in the 1920s.

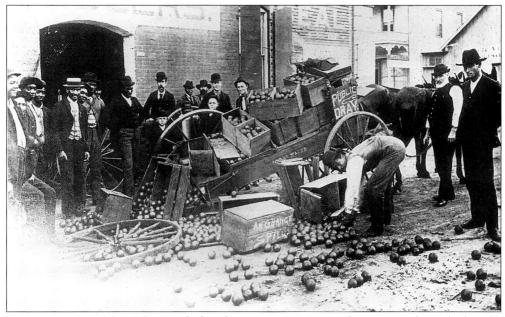

Fruit was gathered by pickers and placed at various points in the grove to be picked up by
wagons and taken to the packinghouses that were usually located near railroad stations. A grove
owner loaded this public dray with too many boxes in an effort to save time and money. What
a mess all those oranges made in the street when the wagon lost its wheel!

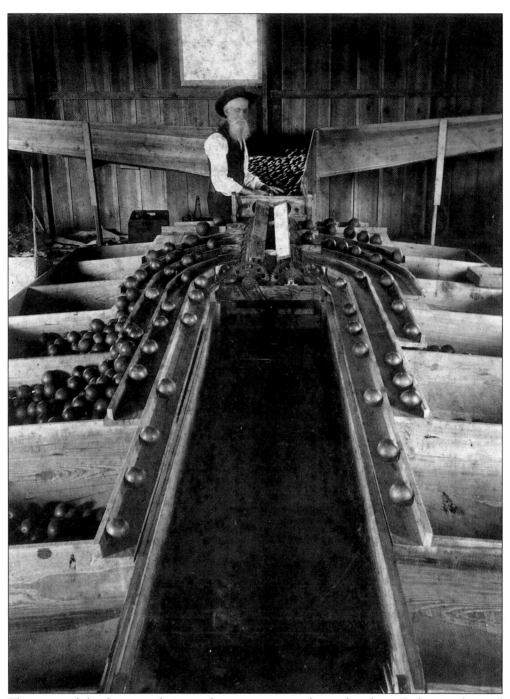

The sizing of the fruit was the second most important facet of packing. Before mechanized sizers, fruit was sized by using a board with holes cut to represent the various size categories. One of these was shown on page 44. The first sizer to be used in Florida was invented by H.B. Steven in 1881. The orange sizer pictured here was invented by James B. Crum in 1905. The device was made in three sizes, sold for $35, $40, and $45, handled 40 to 60 crates of fruit per hour, and was very easy to use. (Florida State Archives.)

In the late 1880s it was discovered that curing helped toughen the fruit's skin, making it easier to ship the produce without much damage. Curing involved letting the fruit sit, usually in a field box, in a cool, dry, well-ventilated place for two to six days. Then the fruit was ready to begin its way through the packing plant.

Later, the fruit was painstakingly washed, scrubbed, dried, sorted, wrapped, and packed in the packinghouses. Two of the largest packers were Dr. P. Phillips and A.J. Nye, who held the patent for a citrus washing machine. This photo shows the fruit rolling down conveyors in Dr. Phillips's plant.

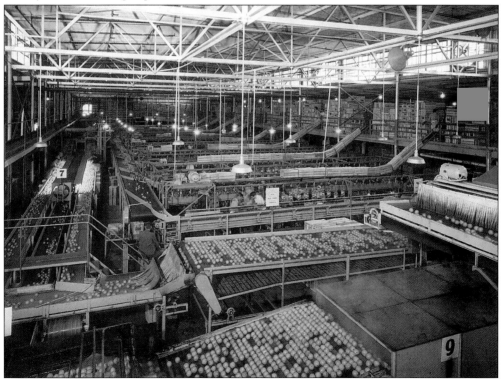

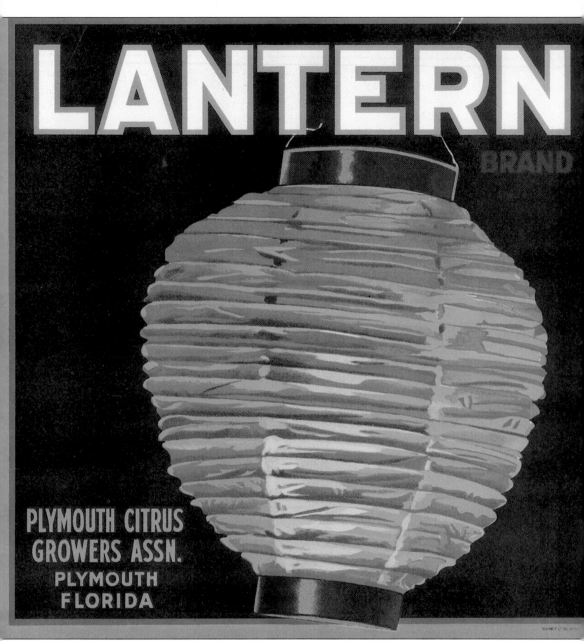

The Plymouth Citrus Growers Association was organized in 1909 and became one of the largest citrus producers in Central Florida. Plymouth was one of the first associations to use trucks instead of mules to haul fruit from the groves to the packinghouse. Before labels were used, boxes were identified by the grower's name painted on the end using a brass stencil. As the industry became more competitive, a much fancier and attention-getting form of advertising and identification was used. There is an art to "reading" the labels that were put on the ends of the boxes. In theory, colors designated the grades of oranges. Blue represented the top grade or number one, red represented the medium grade, and bronze or brown was third rated. Labels were used primarily between 1880 and 1960. Today, citrus labels are popular collectibles and can be quite valuable.

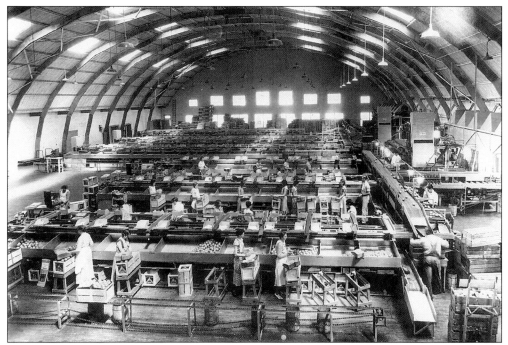

A.J. Nye built his packinghouse on Boone Street in Orlando in 1908, but in 1928 Dr. P. Phillips and Co. built the world's largest citrus packinghouse ten miles southwest of Orlando. Phillips also owned more citrus acreage than anyone in the state at that time.

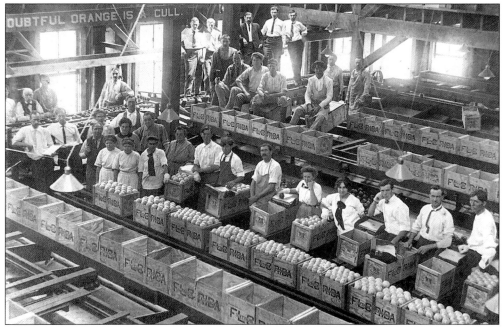

From 1890 until the 1950s, each piece of fruit was wrapped individually in tissue paper to help protect it and to catch the eye of the prospective buyer at auction. Packers of Florida fruit were ever mindful of quality as shown by the sign over the workers reminding them to take the doubtful oranges out of the crates.

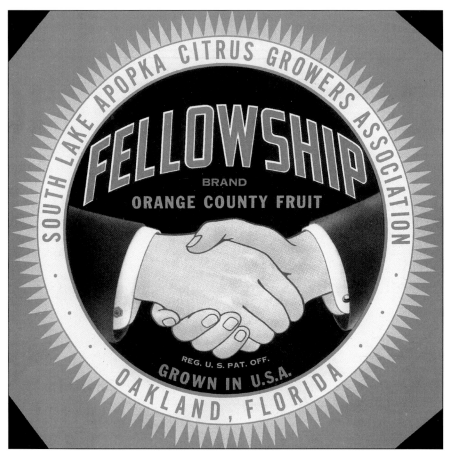

This Fellowship brand label belonged to Lake Apopka Growers and was registered with the Florida Citrus Commission. The first fruit cooperative in Apopka was organized in 1909. Both the Fellowship label and the previous Lantern label were predominately red, indicating a medium grade of fruit.

Florida labels were usually nine inches square with a smaller, rectangular strip label for tangerines. The earliest wooden boxes used for citrus held two bushels. Because it took two men to lift a full box, the industry cut the size back to a two-compartment box, which holds one and three-fifths bushels. The tangerine boxes are only half as deep, and two boxes are strapped together for shipping.

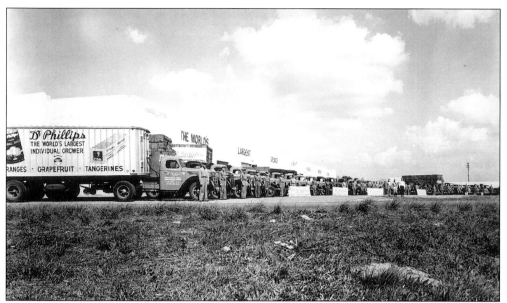

In 1934, the Federal Marketing Act for citrus was passed, regulating the interstate shipment of citrus fruits and the sorting standards for grade, size, and quality. Most of the reputable packers in Orange County were already grading their fruit and assuring the highest quality possible by this time. Here are Dr. Phillips's trucks, packed and ready to roll to customers.

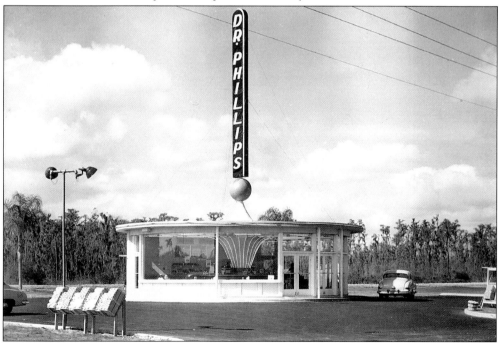

Phillips roadside stands were well stocked with the best in oranges, grapefruit, and tangerines, as well as juices of the fruits. In 1927 Dr. Phillips perfected a flash pasteurization process for orange juice, which retained the vitamin C content of the juice. He was a pioneer in the canning of citrus juices and, until the sale of his groves and packinghouses to Minute Maid in 1954, was the world's largest citrus grower.

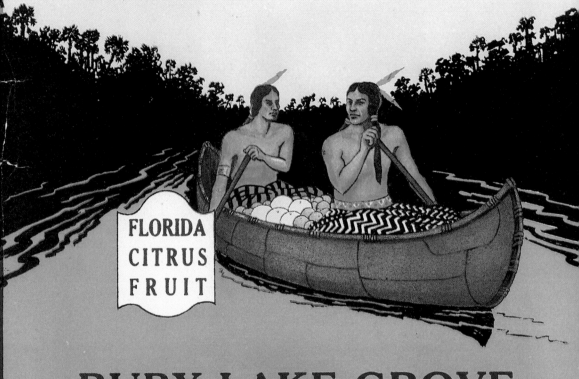

Forrest B. Stone

FLORIDA CITRUS FRUIT

RUBY LAKE GROVE
MAITLAND, FLORIDA

Early label images conjured up beautiful and romantic scenes of lush Florida and served to advertise the state to the rest of the country as a tourist destination. Early designs of soft pastels, featuring babies and flowers, were designed to appeal to the housewife. When the packers realized that it was the men who first chose the fruit, designs changed to appeal to the wholesale buyer with pictures of Indians, hunting, ships, planes, and pretty girls. Forest B. Stone grew and sold citrus from the Ruby Lake Grove and owned a Texaco Service Station in Maitland. His labels featured his name and the early inhabitants of the area.

Three

FUN IN THE SUN

In the county's infancy, sun, fresh air, and quiet company were enough to lure tourists in the winter. Entertainment was simple and mainly held in the several hotels in Orange County, but by the 1880s, Orlando and Winter Park began to develop a strong tourist industry. Both communities had a variety of amusements to entertain their winter visitors and to keep them in town during the whole season.

Among residents, weddings were big events and often lasted for days. People came from all over to attend. Other popular pastimes were church socials and all-day picnics, especially at Clay Springs. The church was the social center of life in the county just as it was all over the country at that time.

The Orlando Board of Trade provided a tourist headquarters during the winter season. Centrally located, it was equipped with tables, papers, and periodicals. Games of the day, such as checkers, dominoes, cards, and chess were provided, and an attendant was constantly on hand to see that everyone was comfortable.

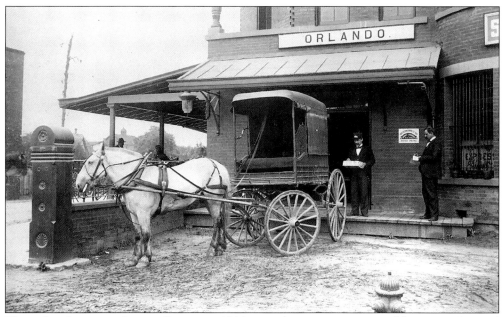

The railroad came to Orange County in 1881, providing transportation of fruit to market and also making it easier for winter guests to travel south to the sun and easy living. Here, a buggy awaits its passengers at the Orlando depot, perhaps to deliver them to a local hotel.

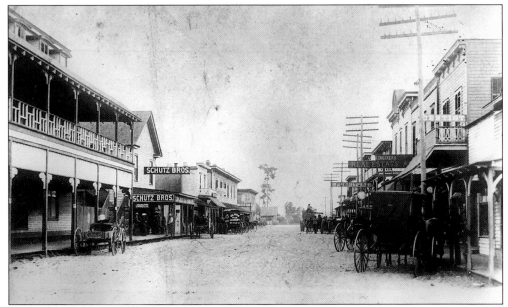

This 1886 view, looking south from Pine Street, depicts Orange Avenue in Orlando. At one time, the Charleston House, shown on the left, and the Magnolia Hotel were political headquarters for local and state conventions. They were situated diagonally across the street from each other. By that time, there were many large, comfortable hotels in Orlando.

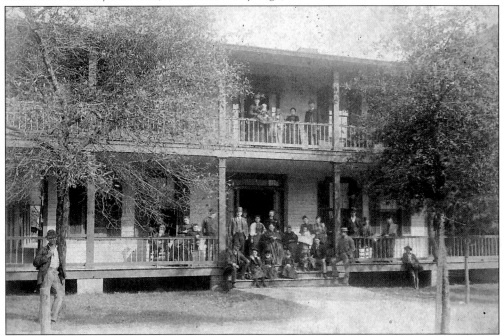

The Magnolia Hotel was built in 1881, and this photograph was taken in 1884 when the hotel was the social center of Orlando. Can't you envision the Orlando Cornet Band playing on that second-floor veranda on a balmy spring evening? This building was later moved, first west and later north, when Elijah Hand bought the property for his furniture store. It ended up as a warehouse for the Hand firm.

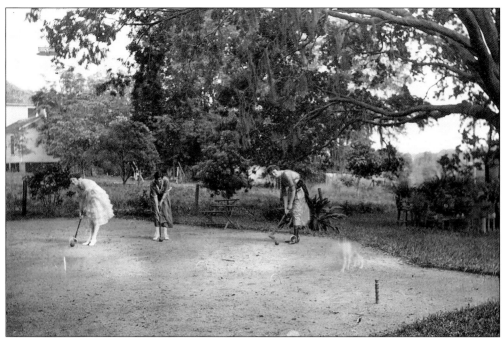

Croquet was always a popular pastime at the winter hotels as well as in the gardens of individuals. This court has been specially prepared by removing the grass to leave a sand base—the better to knock your opponent's ball out of bounds!

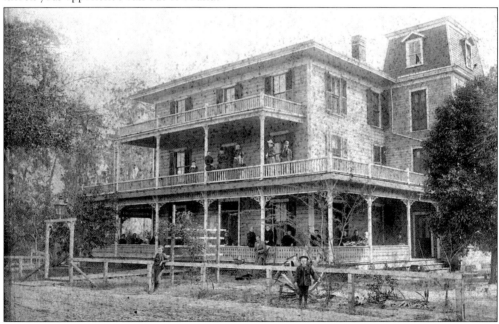

When Loring A. Chase laid out the town of Winter Park, he knew that the beauty of its lakes and forests and the climate would be powerful magnets for winter guests. The Rogers House, built in 1882 to house about 20 guests, was the second building constructed in Winter Park; the first was the rail depot. The hotel was in use under various names until 1966 when it was dismantled.

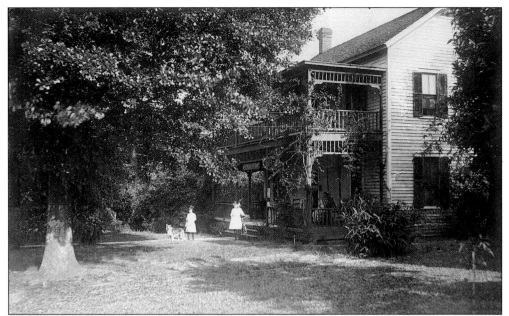

Lakeview House was built on Central Avenue in Orlando across from Lake Eola sometime before 1879 and was run by a Mrs. Shaw. Later, newspaperman S.B. Harrington operated the hotel. This photograph was taken by H.A. Abercromby, whose photos of Orlando and the surrounding area in the late 1800s show off the region's beauty.

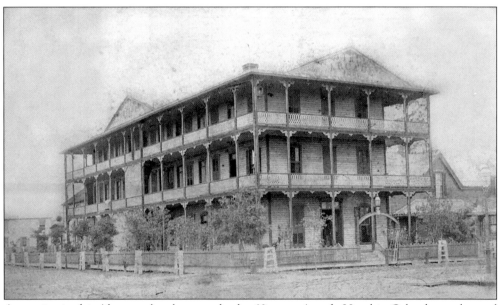

Appearing in this Abercromby photograph, the 60-room Arcade Hotel in Orlando was located at the northwest corner of Orange and Robinson Avenue. It was advertised as "spacious with well furnished rooms, a number of which are equipped with private bath . . . The house is provided with all modern conveniences and the rates are 75 cents per day and upwards."

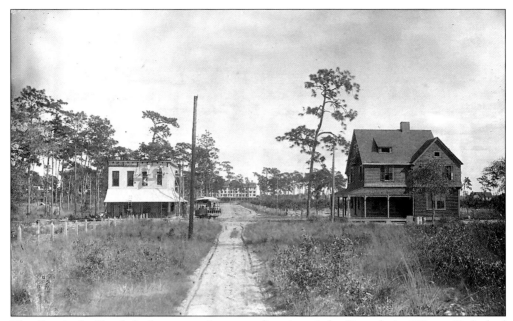

The Seminole Hotel, built on a point extending into Lake Osceola in Winter Park, had accommodations for 400 guests. It opened on January 1, 1896, and operated until September 1902, when it burned down. This view of the hotel was taken from the rail line, and the tracks that are visible belonged to the tram that ran from the depot to the hotel. Famous guests included both President Chester Arthur and President Grover Cleveland, who spent his honeymoon at the hotel.

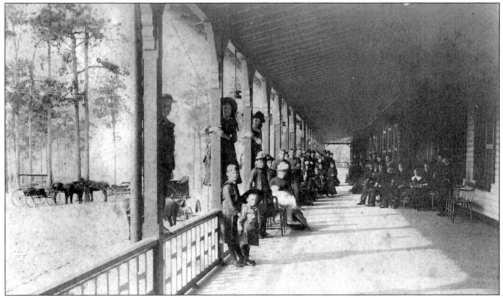

Here we see people on one of the Seminole Hotel's verandas. The hotel advertised that all rooms were equipped with private baths and that the hotel had electric lights, elevators, billiard rooms, sun-parlors, and spacious verandas. The hotel was also known for its gourmet food and hotel orchestra. Daily rates began at $6, making this one of the more expensive hotels in the area.

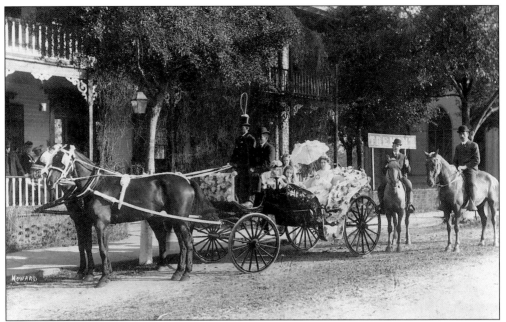

This wedding carriage sits in front of the Tremont Hotel, which was located at the corner of Main and Church Streets in Orlando. This 50-room hotel was home to several permanent guests and regular winter residents, as well as honeymooners. Some residents enjoyed living there so much that they stayed as long as 27 years! Hotel owner Capt. J.W. Wilmott and later his daughters certainly knew how to keep their customers happy.

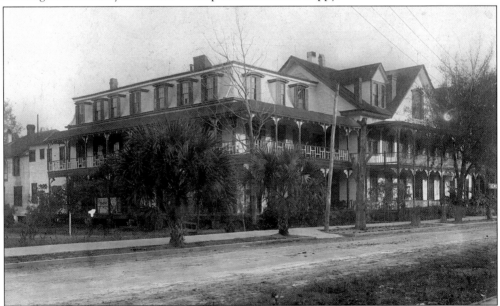

The Tremont represented the ultimate in recycling. The three-story south section of the building served as Orange County's third courthouse until 1892, when it was moved to this final location. The section to the left was half of the old Charleston House that was moved and attached. The county's first school building, a one-room wooden structure, was also bought and moved to the site to be used as a kitchen.

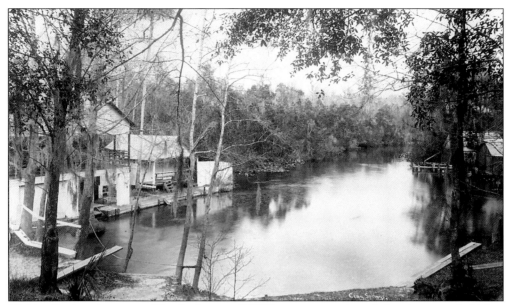

Wekiva Springs, known as Clay Springs until 1906, was a natural pool of spring water bubbling up on the north side of a hill located 13 miles north of Orlando and 3.5 miles from Apopka. The spring is sheltered beneath palm, cypress, and shady oak trees, and the water flows into the winding Wekiva River.

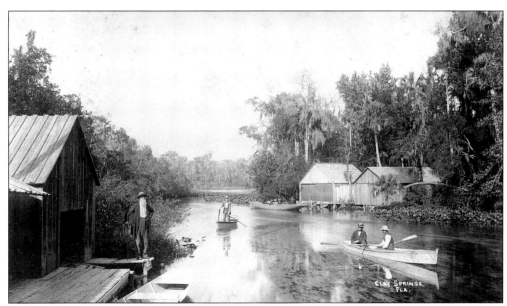

The spring could be reached by boat from the Atlantic via the St. Johns and Wekiva Rivers and was a popular destination in the late 1800s. J.A. Smith built a large tourist hotel near the springs and people would travel four hours over sandy, rutted roads from Orlando for an all-day outing at the spring.

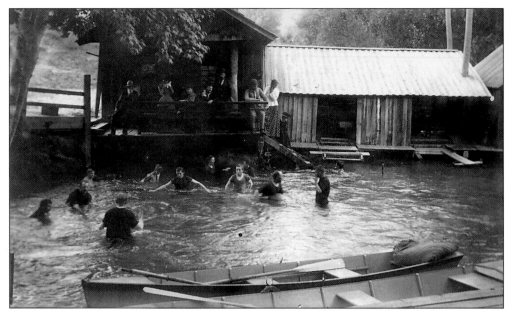

These men bathe in the spring's constant 74-degree water. The springs boil up 48 million gallons of pure, sparkling water each day. Because the water has a high sulfur content, the spring was looked on as a health resort, and many visitors took along containers to collect water for use at home.

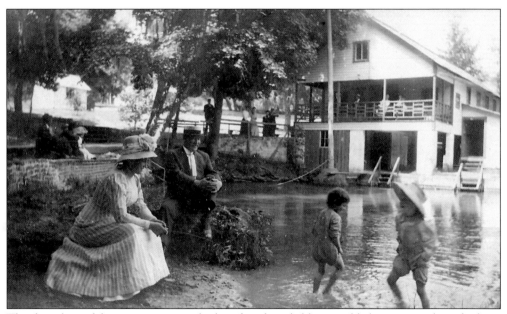

The shore line of the springs was gently sloped so that children could also romp in the refreshing water. Steamers advertised a trip of "Twenty-eight miles of the most beautiful, picturesque trip in the state of Florida. From Sanford across lake Monroe, down the St. John's to the mouth of the Wekiwa [sic], twelve miles; then up the Wekiwa [sic] river sixteen miles to 'NATURE'S WONDERFUL FOUNTAIN' Wekiwa [sic] Springs the 'Pride of Orange County'. A short, comfortable, delightful trip."

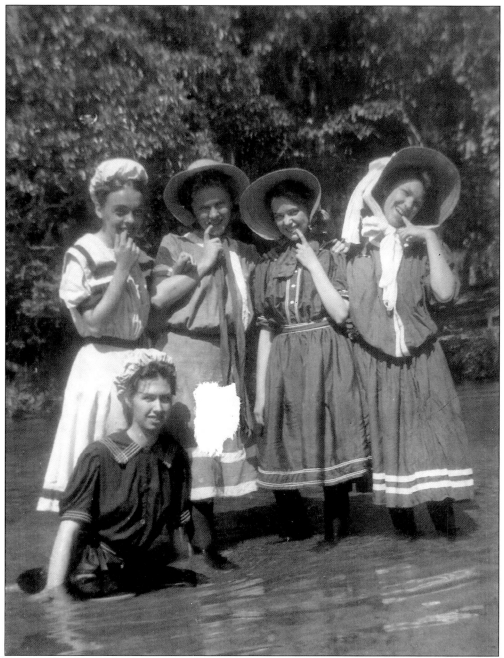

Maj. John B. Steinmetz moved to Clay Springs in 1882 because of his poor health; he wanted to hunt, fish, and live out in the open. He must have enjoyed it for he lived in the area for 67 years! Steinmetz later leased the hotel and springs for development as an amusement park, the first in Orange County. After he added several boathouses, a bathhouse, picnic and dance pavilions, and a toboggan ride, Wekiva Springs became the most popular recreational center in the area. These young bathing beauties delight in the refreshing water, though serious swimming in those cumbersome bathing costumes and stockings was all but impossible. The display of bare flesh was considered shocking, even at the beach.

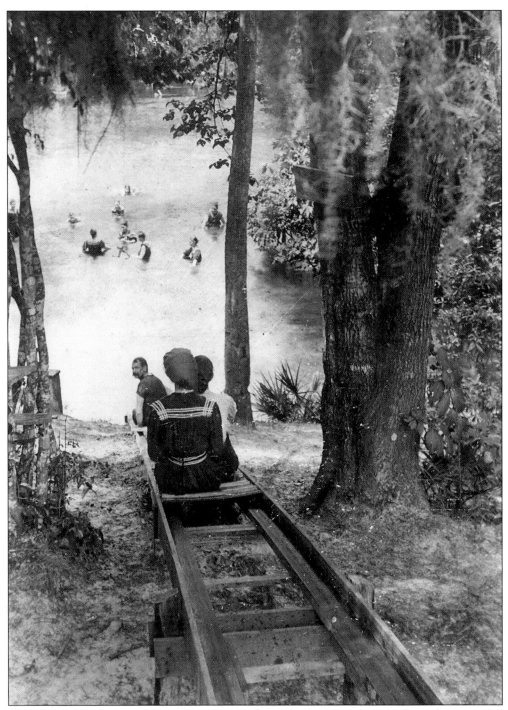

The toboggan slide was a popular attraction and gave bathers an exciting ride, gathering speed as it rushed down the hill and skipped over the boil of the springs. "Shooting the Chutes," as the ride came to be known, was even more exciting when a prankster reversed the toboggan and the rider was dumped into the water instead of sliding over it. Young people today still have fun shooting the chutes.

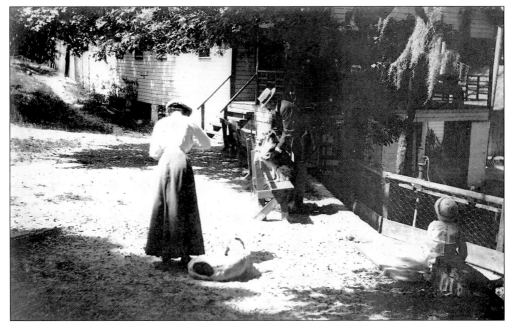

T.P. Robinson and his wife were popular commercial photographers who specialized in portraits. They took "busmen's holidays," always taking their cameras with them. Their daughter and their dogs were favorite subjects. Here, T.P. photographs Mrs. Robinson as she photographs two of their dogs at Wekiva Springs. The other figure is probably their daughter Laura, waiting patiently for her turn.

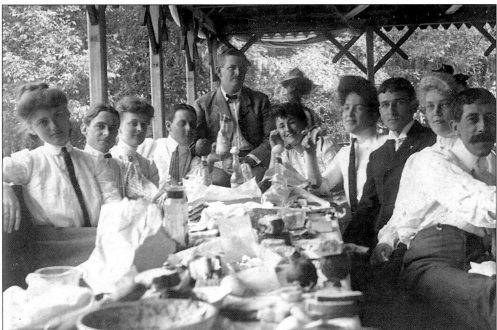

Here is a group in the picnic pavilion after a grand meal. Outings such as this were all the rage in the late 1800s. Identified are Lilly Wilmott, on the far left, and Mrs. Evans and Don Beidler, on the far right.

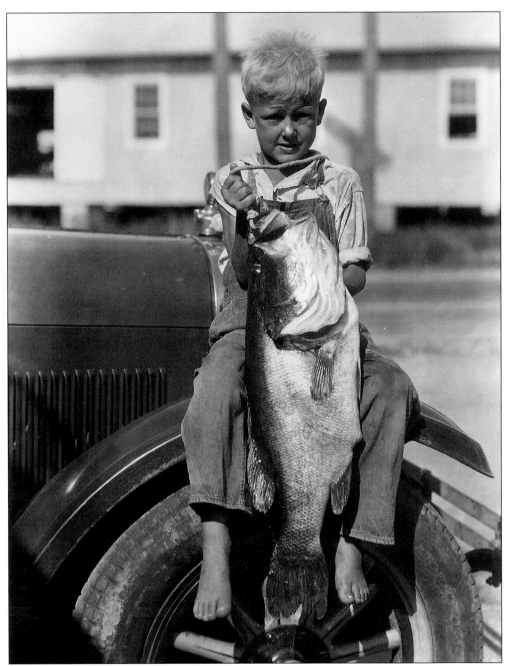

This boy holds a 13–15 pound Florida black (or large-mouthed) bass. Photographing a fish next to such a small figure makes the fish appear even larger. It was advertised that the fish were so plentiful in the lakes of Orange County that they practically jumped into your boat. This type of bass is the fish that continues to attract 90 percent of the fishermen who vacation in Orange County, and it has given the county the title of Big Bass Capital. Black Bass, which grow year-round in Orange County because the water temperature stays near 76 degrees, can be found in deep or shallow water, with their location depending upon the air temperature. This species of fish has been transplanted to other areas of the country, especially Texas and California.

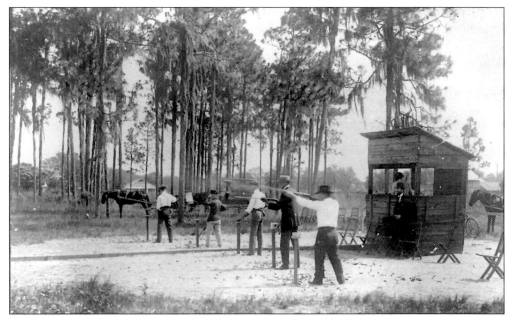

Hunting was another of the major early attractions of the area. This Orlando Gun Club tournament was held on October 24, 1907, and several men have arrived by bicycle or by horse and buggy.

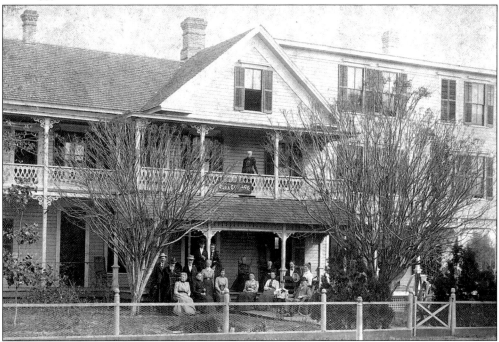

Eola Cottage began as the home of Mr. M.L. Knight, who moved to Orlando in 1884. In 1900 Miss Hannah Paul moved to Orlando to find a place to open a hotel, purchased the Knight house, remodeled it into a 30-room hotel, and named it Eola Cottage. Paul also managed a hotel in the Catskill Mountains in the summer months, and it was said that she made people feel so at home in Orlando that her hotel was always full.

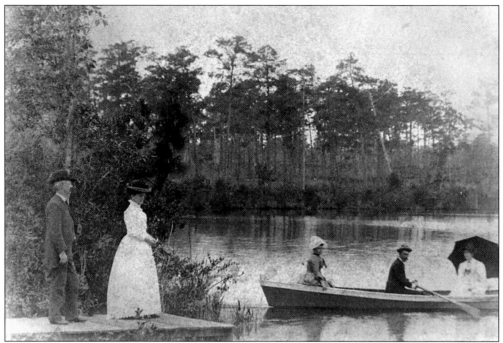

Boating on Lake Apopka was a popular pastime for those in the hotels close by as well as for the locals. Boaters and fishermen had to be careful not to get too far out for the weather could turn dangerous quickly in this, the second-largest lake in Florida.

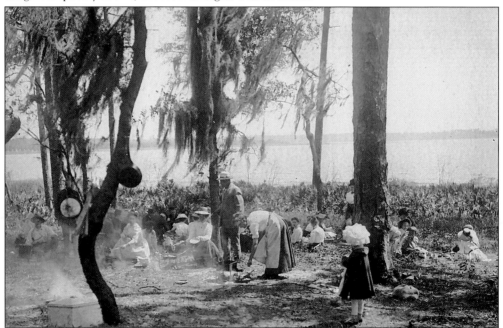

Here, a party prepares to enjoy the fruits of their fishing labor in 1909 on Lake Down near Windermere. Although the cooking arrangements are rather primitive, notice how well dressed the chefs and onlookers are, particularly the little girl to the right. This was typical of the age, everything done in public was an occasion to dress up.

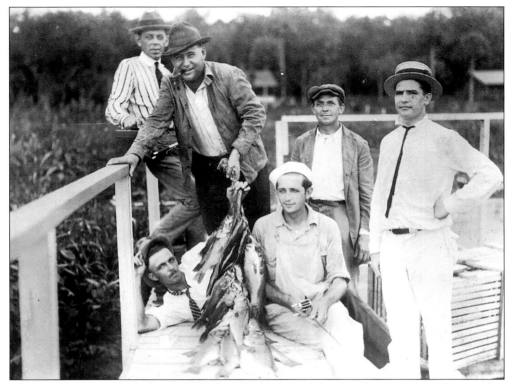

These men appear satisfied with their day of fishing on Lake Apopka. It is quite clear, in this image, which men were the guides and which were the visitors. Who do you think did most of the baiting and fish handling?

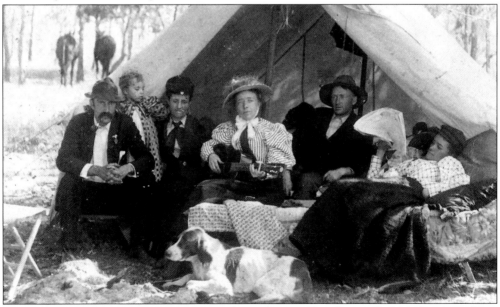

Here is a group that has gone camping on Lake Butler in style! They took along their easy chairs and musical instruments. Camping became more popular when more people were motoring into Florida instead of traveling by rail.

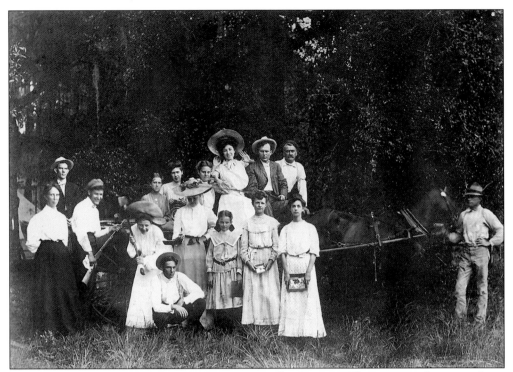

This 1905 party is going fishing at a camp on Lake Conway. The young girls are ready to practice their needlework in the shade while the men fish. Some of the women look as if they will also fish from the shore. Fishing wasn't just for the visitor. The locals often enjoyed the sport and would often go out together as a party, fish and hold a cook-out similar to the one shown on page 66.

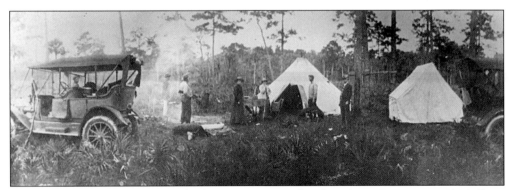

The Cheney party was photographed camping at Tosohatchee Game Preserve in 1914. From left to right are Judge J.M. Cheney (with a gun), Mrs. J.M. Cheney, Mrs. J.Y. Cheney, J.Y. Cheney, and W.R. O'Neal. The following year, Cheney and some friends organized a hunting club to purchase these ranch lands to use as a game preserve.

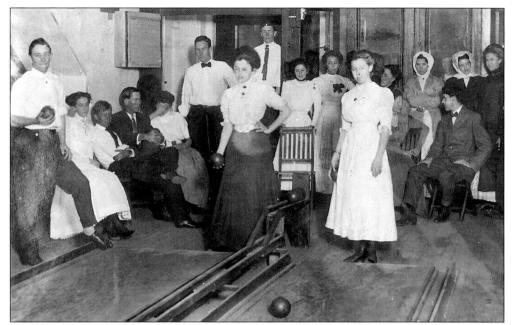

Mr. Van Brunt owned this two-lane, indoor bowling alley located at the northwest corner of Pine and Court in Orlando. When this picture was taken around 1910, pins would have been set by hand as they would continue to be for the next 50 years. Notice the size of those balls— quite a different sport from bowling today.

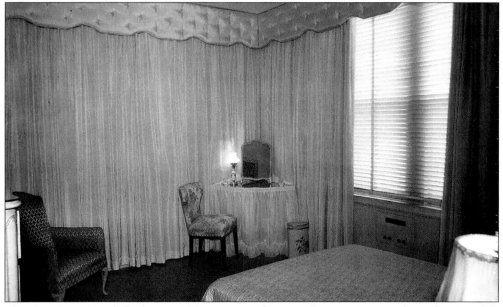

The San Juan Hotel, built in 1885, once stood across Orange Avenue from the Angebilt Hotel, which was built in 1923. The Angebilt was Orlando's first skyscraper at 11 stories high. After the San Juan added an 8-story tower, the two hotels had a rivalry, each claiming to be ritzier. This photograph depicts one of the Angebilt's 250 rooms, which were very plush indeed. The Angebilt building has been preserved although it is no longer a hotel. The San Juan was demolished.

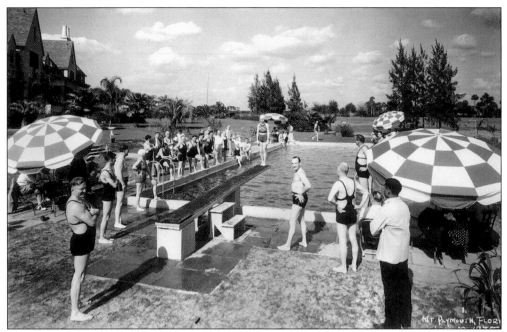

Mt. Plymouth Hotel was built as "Florida's Golf Center and Playground City" in 1925, and what would a hotel stay be without a nice swimming pool? This large pool was well used, especially in the hot summer days.

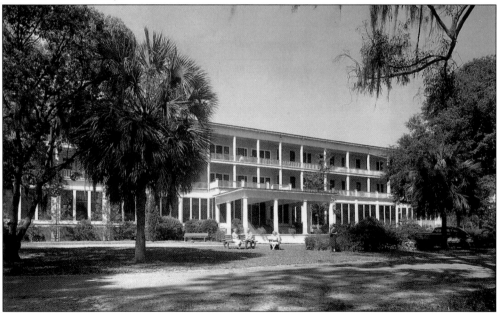

This view shows the second Lucerne Hotel. The first had burned down in 1886, and Robert S. Rowland built this "New" Lucerne in 1907. In the beginning, the hotel was filled with bachelors, mainly young businessmen, attorneys, and traveling salesmen. With a change in ownership in 1939, the hotel became a place of winter residence for retired people. The hotel was knows for its azaleas, nine porches, and excellent personal service. It was torn down in 1966.

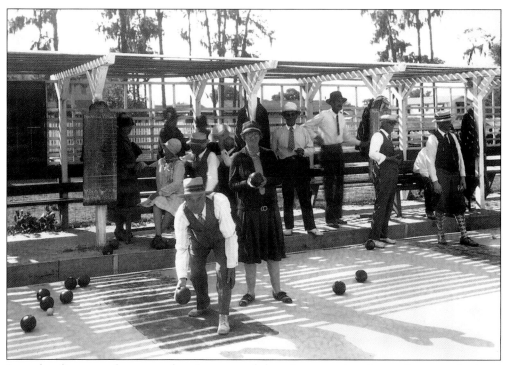

Lawn bowling soon became a favorite sport of the winter tourists. It was first organized and space was provided by the hotels, but by the 1920s, pubic bowling lawns were set aside for the tourists and residents alike.

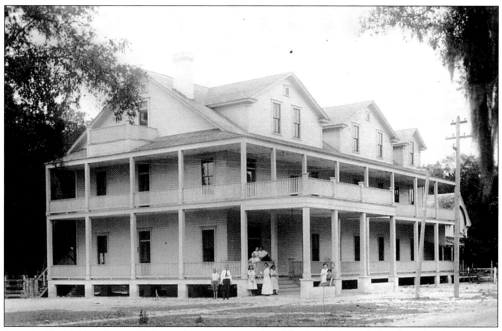

The Oakland Hotel was a Mecca for sportsmen who liked to fish on Lake Apopka. Boats were available for hire as were guides for larger parities. This photograph, taken in 1912, shows some of the women and children who were left behind while the men went fishing.

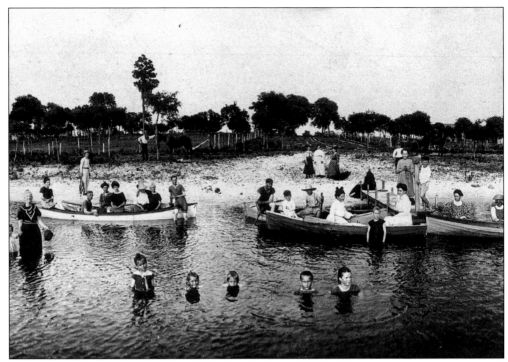

While fishing was generally considered a man's sport, swimming and boating were enjoyed by both genders. It could be that the men and women in the boats in this picture are watching their children show off what they have learned in swimming lessons.

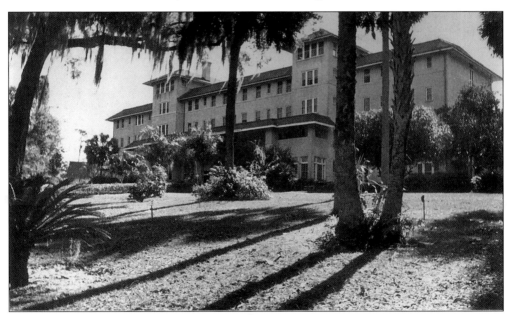

The Alabama Hotel was built on Lake Maitland off Palmer Avenue in Winter Park in 1922 as a no-frills, comfortable, 66-room hotel that catered to winter guests. Among the notables who wintered here and rocked on the porches were orchestra conductor Leopold Stokowski and authors Thornton Wilder and Margaret Mitchell.

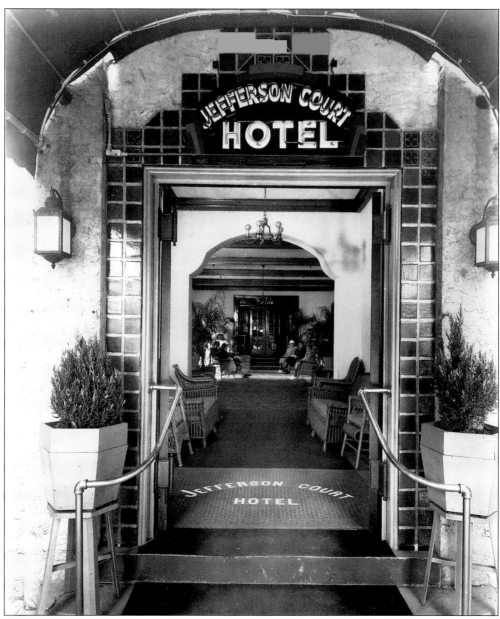

A group of Orlando businessmen organized the Orlando Investment Company to finance the building of the Jefferson Court Hotel. This civic-minded group included L.L. Payne, president; E.G. Duckworth, H.H. Dickson, and James C. Patterson, vice presidents; Charles P. Dow, secretary; and S.Y. Way, treasurer. Directors were J.F. Ange, H.L. Beeman, J.M. Cheney, Dr. C.D. Christ, E.W. Davis, Harry P. Leu, H.H. Dickson, Charles P. Dow, V.W. Estes, J.L. Giles, W.E. Martin, Dr. J.S. McEwan, John McCulloch, M.O. Overstreet, J.C. Patterson, L.L. Payne, I.W. Phillips, Dr. P. Phillips, Walter W. Rose, and S.Y. Way. This 1918 hotel was the first apartment hotel and advertised "such modern conveniences as disappearing beds, hidden kitchen cabinets and an icebox in every apartment." The lobby also looked inviting to visitors. The landscaping included spacious lawns, flowers, and benches in the courtyards between wings of the building.

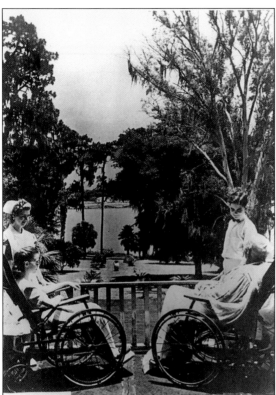

One of the earliest reasons people came to Central Florida was for their health. The most popular treatment used at the turn of the century for diseases such as tuberculosis called for lots of rest, sunshine, fresh air, and mild exercise—all were available in Orange County. These patients rest on the veranda with a view of the lake.

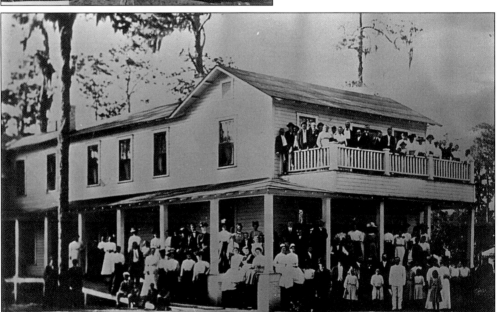

This 1909 view shows the Florida Sanitarium where one could go to rest and recuperate from illness. Orlando information brochures advertised that those afflicted with disease would find relief, that the invalid could have a new lease on life. The early ad ended with "If you are sick, come and get well, if well come where you can keep so." This institution was the beginning of what would become Florida Hospital.

Four

COME TO VISIT, COME TO STAY

Advertising is an ancient skill practiced over the centuries, but it was never so developed, refined, and creative as at the height of the Roaring Twenties in the United States. No frontier area in the nation has been so widely advertised as Florida. The Orlando Board of Trade paid for extensive advertising campaign in the newspapers of important cities to attract business and industry to the area. Repetitive mass advertising in magazines, in newspapers, and on the radio helped to create the land boom that reached its zenith in 1925.

But newspaper and magazine ads weren't the only methods used. Word of mouth continued to be important in drawing new settlers and tourists to Orange County. Men such as Will Wallace Harney sent columns to Northern papers and magazines touting the wonders of Orange County. Well-known people such as Presidents Grant, Arthur, and Cleveland sent glowing reports of the area home. And, of course, all those winter residents sent postcards home telling of the wonderful area they had chosen.

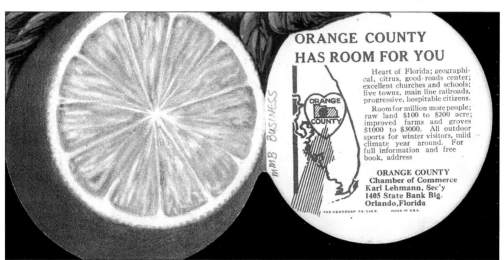

A monument erected in Orange County advertised "Pure water, good roads, no mosquitoes, no malaria." Orange County has always aggressively sought new residents and businesses to settle in the area, and this is but one of the pieces that was mailed to prospective visitors and settlers.

75

WINTER PARK
ORANGE COUNTY
FLORIDA
"The City of Homes"

PUBLICITY DEPARTMENT
ELLA S. KENNEDY, SECRETARY

Winter Park, Florida

FLORIDA

To the Homeseeker and Tourist:

WE wish this circular to carry a cordial invitation to visit WINTER PARK, "The City of Homes," and enjoy the hospitality which awaits you.

We want the opportunity of showing you one of the most delightful, healthful and progressive communities in the State of Florida, beautifully situated in the highest region of South Central Florida, in Orange County, amidst lakes and golden groves.

It is "The City of Homes," with beauty unrivaled. Palatial residences and estates of people of prominence adorn the shores of beautiful lakes. It is a paradise for those of humbler means.

Write for booklet and detailed information.

———

From the beginning, letters such as this were mailed to potential settlers and tourists all over the United States. At first they wrote of sunshine, cheap land, and gracious living. They still do mention these things but now also advertise condominiums and golf communities and are printed in many colors on slick paper.

This postcard of a pineapple field in Florida is part of an artistic series published by H.&W.B. Drew in Jacksonville, Florida. There was a time when it was thought that pineapples would be a good crop for Orange County but insects and competition from Cuban planters made farmers turn to other crops.

Some enterprising photographer promoted the area by printing the photographs of the children of locals and tourists on postcards. What a cute memento to send home to those who couldn't make the winter visit to sunny Orange County.

This poem, entitled "Orlando," was printed on postcards and in publications to show the way the locals felt about their hometown. Winter tourists soon came to view the area in the same way. These visitors came to enjoy the slower, simpler lifestyle and often returned to the same hotel or guesthouse year after year.

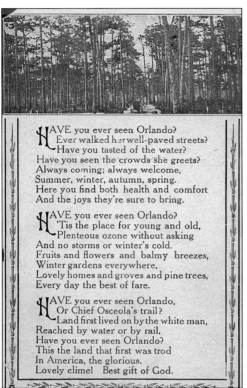

HAVE you ever seen Orlando?
Ever walked her well-paved streets?
Have you tasted of the water?
Have you seen the crowds she greets?
Always coming; always welcome,
Summer, winter, autumn, spring.
Here you find both health and comfort
And the joys they're sure to bring.

HAVE you ever seen Orlando?
'Tis the place for young and old,
Plenteous ozone without asking
And no storms or winter's cold.
Fruits and flowers and balmy breezes,
Winter gardens everywhere,
Lovely homes and groves and pine trees,
Every day the best of fare.

HAVE you ever seen Orlando,
Or Chief Osceola's trail?
Land first lived on by the white man,
Reached by water or by rail.
Have you ever seen Orlando?
This the land that first was trod
In America, the glorious.
Lovely clime! Best gift of God.

Orange County was represented by this display at the 1893 county fair. At another fair, photographer H.A. Abercromby chartered a passenger coach, removed the seats, lined the walls with photographs, and filled the car with citrus fruit, pineapples, and other products of Florida to show what a great state it was.

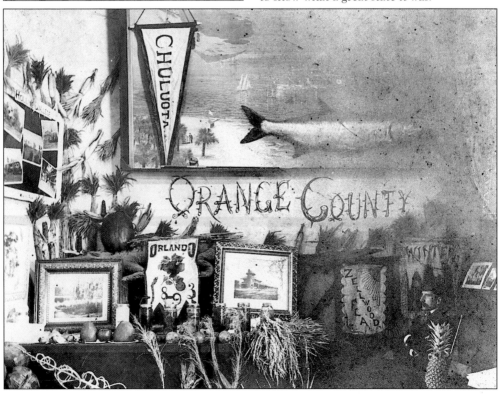

Orange trees and palm trees are synonymous with Florida, and Orange County had its share of postcards of each. These cards were printed in color so you could see the beautiful sunset across the water.

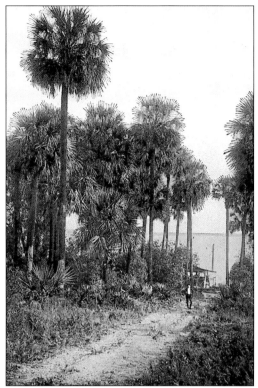

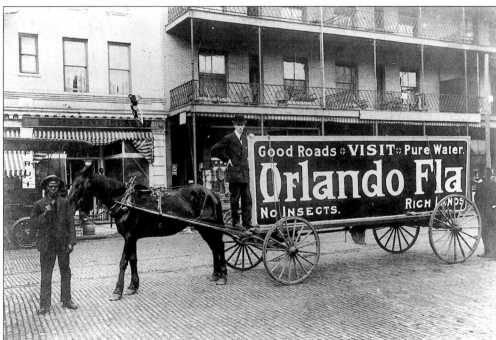

Orlando not only sent advertisements to cities in the North but also targeted cities in Florida. This wagon is thought to have been in Tampa around 1900. Orlando bragged also about being a healthy area, since it had no yellow fever in years when other Florida areas did.

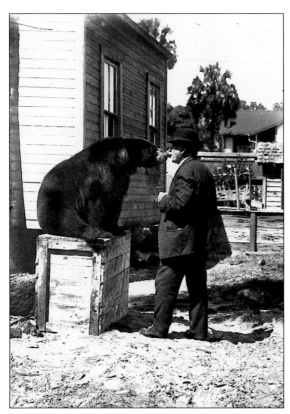

After seeing something like this, tourists went home and talked about the exotic "pets" they had encountered such as alligators, venomous reptiles, and even this kissing bear.

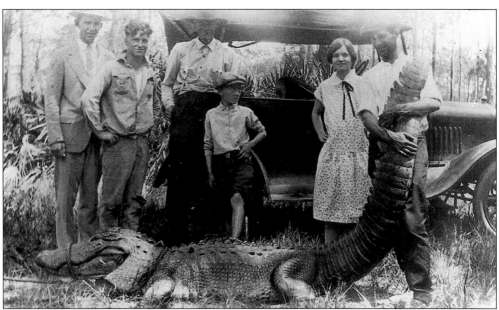

The family probably killed this alligator on a Sunday outing, but in the late 1880s some locals took alligators into town to show them off to the winter tourists who viewed alligators as exotic reptiles. Those who hunted them did so for their meat and leathery skin, which was later used for belts, wallets, and shoes.

When the locals went to check out other areas of the country, they let you know where they were from in a big way! J.C. Brossier was one of this party of Jaycees who toured from Orlando to Pasadena and back.

This gentle reminder to the friends left at home was typical. Notice that it doesn't invite anyone to come visit. These postcards were printed by the thousands and the name of the town was stamped on them after they were printed.

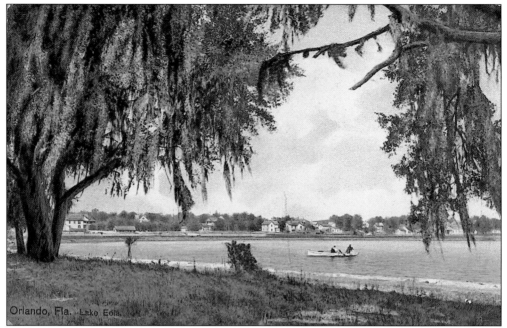

This postcard, featuring Lake Eola, was sent from Plymouth in 1908. As with so many cards of the day, this one was made in Germany and issued through a U.S. manufacturer. The following message was written on the back: "It is so hot here 75 night-but lovely this is an ideal place small Hotel but lovely people joley [sic] and all have a good time."

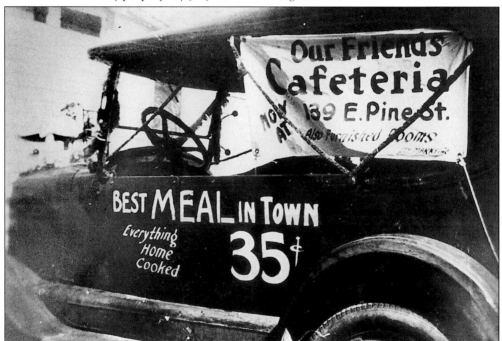

If automobiles were good for advertising Orange County to the rest of the country, they worked just as well to advertise great deals in meals available in town. Driving the ad around town also gave the young man a reason to ride around and see what was happening.

Take a tip and make a trip to ORLANDO *and you will have the time of your Life*

Pretty girls are always popular postcard subjects, and this one was photographed with the orange tree she is inspecting. Messages like this one were also popular for postcards to be sent to the folks at home. This is another card where the name of a town could be stamped on a generic card.

PRIMP AND PRIMP! WORK EACH EARTHLY SCHEME AND PLAN, DO YOUR BEST TO GET A MAN.

in Orlando, Fla.

You can see what was on the minds of some of the young women who wintered in Orlando in the late 1800s! Past a certain age, getting a man was a full-time job. What better place to look for a husband than the winter watering hole of the rich and famous.

This generic greeting from Orlando was sent from Winter Park and gave the recipient many small views of what they were missing. Look carefully at the photographs within the letters to see what Orlando and its people were like when this card was sent in 1912.

The best advertisers for Orange County were often the tourists writing home to their friends, families, and neighbors. They chose postcards that appealed to them and to the intended recipient as can be seen from the wide range of topics shown here.

If any one should ask you, the place to fish and hunt
You tell them Collier's is the place to do that stunt.
Where the sportsman's dream of pleasure can be fully realized,
To dear old Lake Apopka, Florida must give the prize.

EMMA BISCHOFF JOHNSON

The automobile enabled those with modest means to vacation in Florida as well. This postcard promotes the entertainment available at Collier's Grove on Lake Apopka. The visitors who traveled by car often stayed just a week or two, not months, as the wealthier winter visitor did.

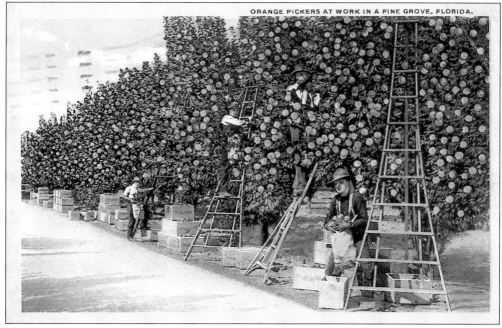

ORANGE PICKERS AT WORK IN A FINE GROVE, FLORIDA.

Thousands of oranges and orange pickers were featured on postcards. This one was posted in 1920 with the following message: "Come south and keep warm. We are having the time of our lives. Just think of the open cars and taking a nice ride every day. On the varandes [sic] every night until 11 o'clock. I hope you and Mr. are well with our best wishes. Mr. and Mrs. J. L. Hooper."

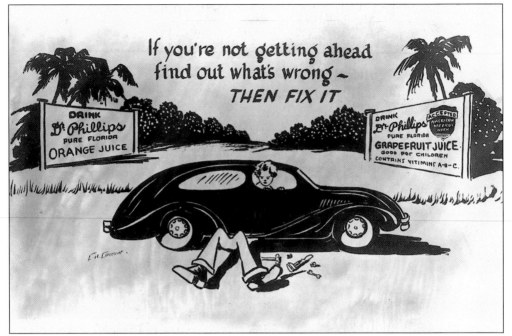

Dr. Phillips probably printed this postcard just after the company's juices were accepted by the American Medical Association as being beneficial to one's health. Phillip's juices were the first to receive this designation.

The town of Christmas is known for its unusual name, and during the Christmas holiday, its post office handles many pieces of mail sent there for the Christmas postmark. The community was named for Fort Christmas, a log structure that was erected by soldiers during the Seminole Indian War on Christmas Day in 1835.

There were many postcards printed for Christmas, Florida, one of which contained the following greeting:

From land of flowers and sunshine,
Where Christmas reigns through all the year
I send this wish for blessings fine,
That you may have the season's cheer,
And love and peace and laughter gay
Through all the year and Christmas Day.

This aerial photograph of Christmas was taken in 1956. Christmas is 25 miles east of Orlando on the Cheney Highway and a crossroads for those in the area who raise cattle and citrus. The Christmas Post Office was established in 1892.

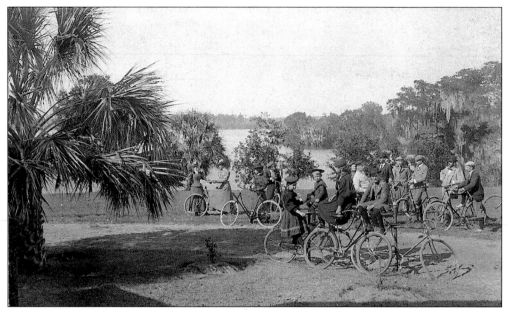

C.E. Howard had a photographic studio in Orlando for about 35 years ending in 1930. He advertised himself as a photographic artist and took pictures, such as this one of a bicycling group on an outing, showing the quality of life in and around Orlando. These images were called "Florida Views."

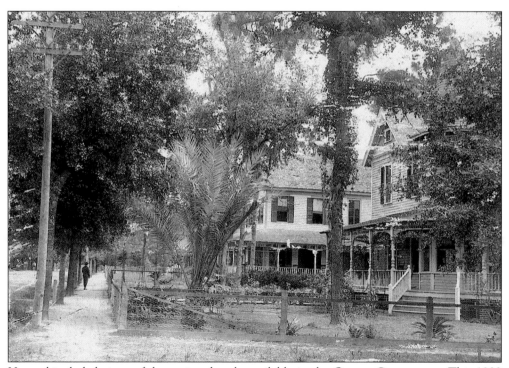

Howard included views of the various hotels available in the Orange County area. This 1902 photograph was taken from the northeast corner of Orange Avenue and Washington and shows the Pines Hotel located beside the house on the corner.

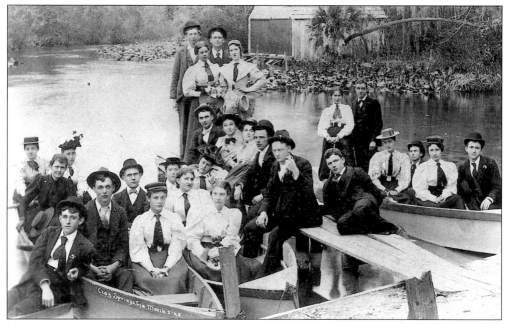

This is an earlier (non-Howard) view of a boating party in Clay Springs taken in March 1893. These were the "bragging photographs" that early visitors took home to show how pleasant the weather was in Central Florida.

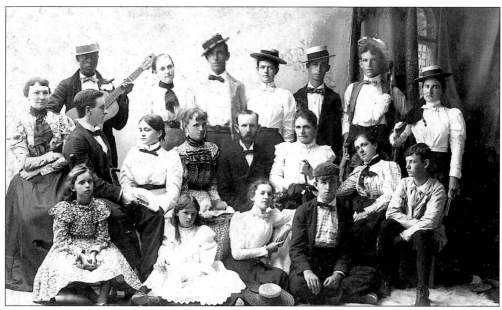

This 1898 Howard photograph shows a camping party in Clay Springs. The man on the left in the back row is Walter Pinknee, the camp water carrier and helper. It looks as though he also provided the entertainment.

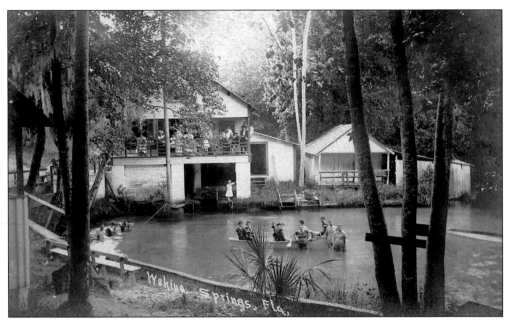

A later view of Clay Springs, now called Wekiva Springs, was taken for the same promotional purpose as C.E. Howard's "Florida Views." This crisp image with the hand-printed location on it looks like a T.P. Robinson photograph.

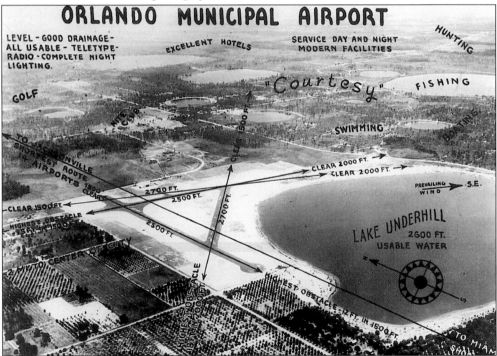

This photograph of the Orlando Municipal Airport with all the area attractions could have been used by the chamber of commerce to attract businesses and residents to the area. The 1930s view not only points out all the favorable features of the airport but also highlights the amenities available nearby.

Five

ORANGE COUNTY ON PARADE

Visitors have always been encouraged to come to Orange County; and at the turn of the century, there were many public events and celebrations to which they were welcomed.

Orlando residents have enjoyed parades and bands since the beginning and the motto has always been the more the merrier! There were always several bands available to provide music, and local musicians sometimes played in many different bands. The bands might play in the band shell in the park or as entertainment in one of the many hotels.

Orlando High School and Rollins College had active sports teams that were enthusiastic and played well for the spectators. Someone was always ready to turn a mode of transportation into sport, whether it was horses, automobiles, or airplanes. And, of course, you must parade out to the sporting event for all to enjoy.

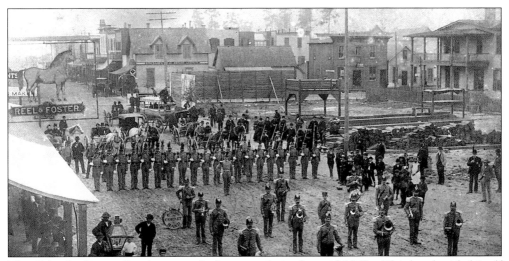

The Orlando Cornet Band gets ready for a parade in the mid-1880s. This band prided itself on having the best-looking uniforms around. Look at the rows of brass buttons and all that braid. The Shine Guards are also lined up and ready to parade. This picture was taken from the balcony of the Cheney Building on the northeast corner of Central Avenue, looking south.

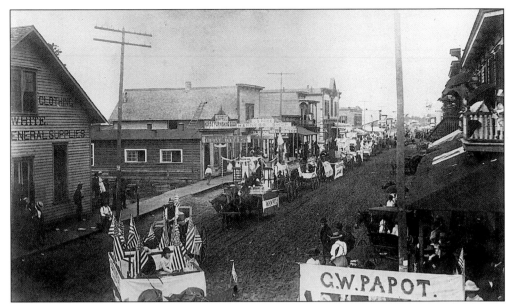

Independence Day was celebrated with this parade in 1886. The wagons with floats on them are pulled by mules and make their way down Church Street to turn onto south Orange Avenue. Church Street was the main thoroughfare in 1886. Many of Orlando's wooden buildings, pictured here, survived the January 12, 1884 fire.

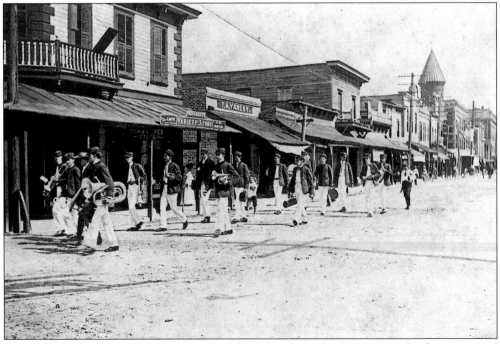

The Orlando Cornet Band, preparing here for a parade in the 1890s, was the first organized band in Orlando. Members pictured here are, from left to right, (front row) Frank Guernsey, unidentified, Harry Newell, Clark Robertson, Owen Robinson, and unidentified; (middle row) unidentified, Paul Horn, and Hang Dickens, and the rest unidentified; (back row) Ben Kuhl, N.J. Merck, unidentified, unidentified, Joe Guernery, and Josiah Ferris.

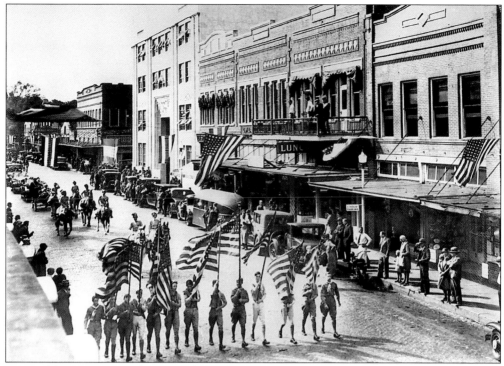

Pictured here is an even later parade, probably a Memorial Day or Independence Day parade after World War I. This photograph shows much improvement to the town center, as three- and four-story buildings of brick and stone have replaced earlier one- and two-story wooden structures.

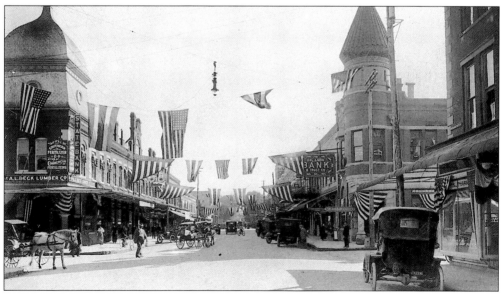

Orange Avenue, in a view looking south from Pine Street, is all decked out for a parade on February 14, 1914. Mid-winter parades were popular because the weather was more enjoyable than that of the summer and because the winter tourists could have another festive day to enjoy.

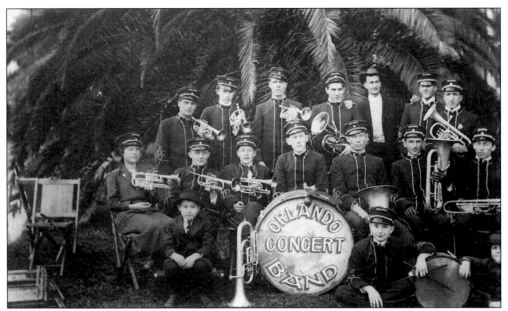

The music of the Orlando Concert Band was popular public entertainment as evident in this 1912 photograph. From left to right are (seated) Weston Dennis (mascot), Carl Daugherty, and John Dennis (mascot); (second row) Loraine Starkey, Henry Raehn, unidentified, John Foster, J. Merle Vieman, Edgar Thompson, and Donald C. Helms; (back row) Jake Burkhart, Charlie Limpus, W.A. Starkey, Harry James, George Jump, and two unidentified people.

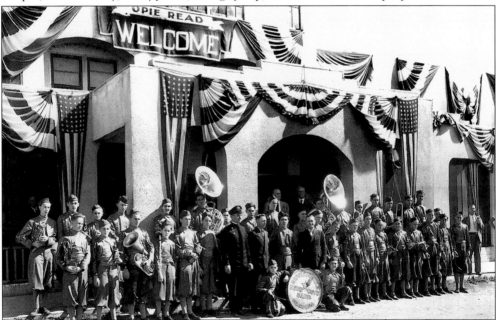

The Orlando Newsboys Band not only played at home but also went "on the road" in the summers, playing in such diverse venues as Chautauqua, New York, and metropolitan centers in the north and east. They even played for President Herbert Hoover in 1928. The band also made local appearances in parades and played concerts in Eola Park. The *Reporter-Star* sponsored the band and dressed the boys in elaborate uniforms.

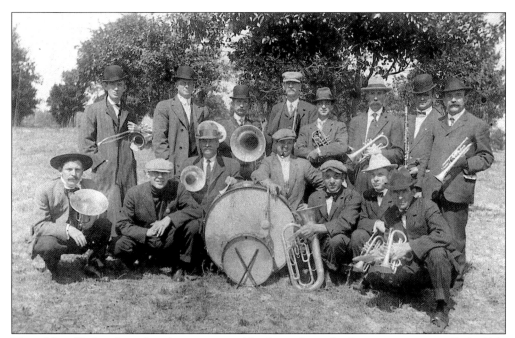

Harry Newell's band was hired to entice and lead people to the Sperry grove east of Lake Eola when it was subdivided into lots around 1911. Shown here are, from left to right, (front row) Payson Branch, ? Fox, George Barker, ? Leach, unidentified, Edmund Allen, and Alex Newell; (back row) John Empie, Paul Horn, E.S. Keyes, F.N. Bordman, John Harvey, two unidentified people, and H.A. Newell.

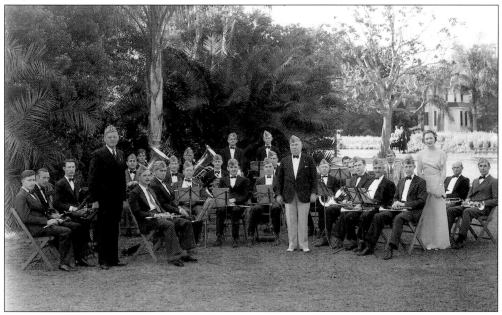

Here, the American Legion Works Progress Administration (WPA) Band sets up to play an outdoor concert on April 19, 1936. The musicians are unidentified but the conductor is T. Warren Berry. The WPA employed many musicians, artists, and writers across the country during the Depression, as well as funded public works such as air field improvements.

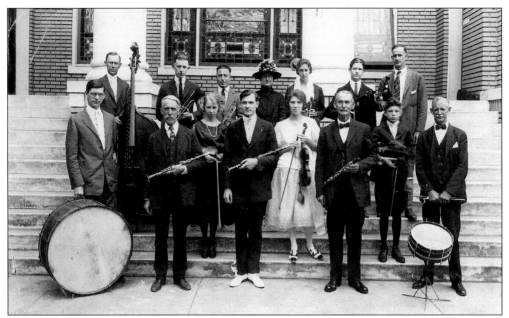

Local churches also sponsored musical groups. Shown in 1920 is the First Baptist Church Orchestra, which was directed by Frank Bordman Sr. From left to right are (front row) S.E. Limpus, Dr. Frank Bordman, Frank Bordman Sr., and E.H. Westover; (middle row) the only person identified is W.S. Branch; (back row) F.A. Hasenkamp, C.E. Limpus, unidentified, Mrs. ? McNeil, Ruth Jump, Mr. ? McNeil, and George Jump.

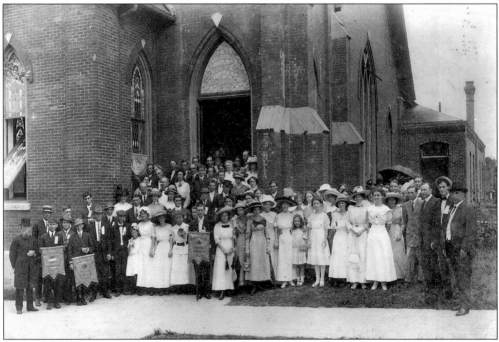

Local churches also welcomed tourists, whether for long-term stays or one-time visits. Here is a gathering of Trinity Methodist attendees, all in their Sunday finest. Trinity was originally the First Methodist Church in Orlando.

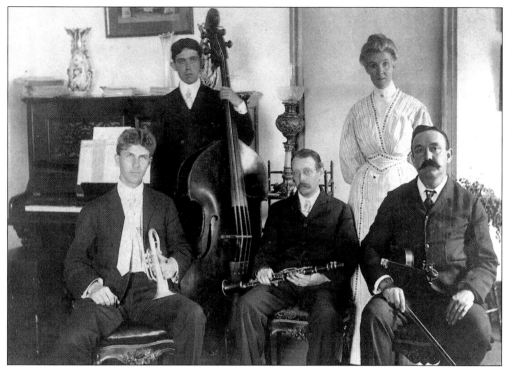

Professor Harry A. Newell was a popular music teacher after he moved to Orlando in 1880. He helped organize bands and an orchestra and played for local dances. Newell is pictured here with one of his bands and his wife, Gertrude (standing).

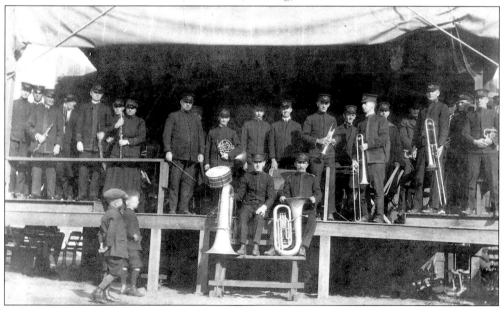

The Knights of Pythias organized an Orange County chapter in 1885, and their objectives were to promote friendship, charity, and benevolence. What better way to promote friendship than by making music together for the benefit of the community? No names are listed on this photograph, but if you look closely, you may see familiar faces from other band pictures.

Music in the park was very popular among visitors and residents. This bandstand was built at Lake Eola in the 1890s to provide shelter for the local and visiting bands that played there, likely including the Orlando Cornet Band, the Orlando Newsboys Band, and the American Legion Band.

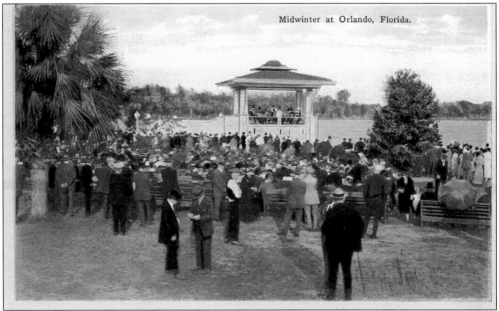

In this postcard view, people enjoy themselves and listen to music around a bandstand in Orlando in mid-winter. Winter visitors sent such postcards to show their friends how lovely the winters were in Florida while snow covered the ground back home.

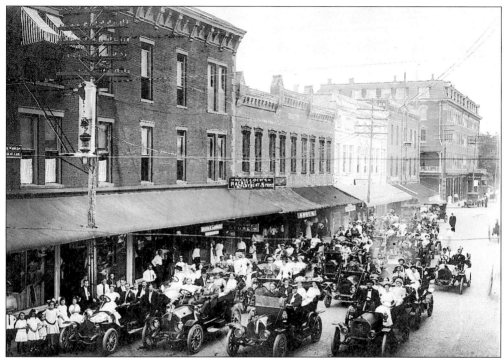

In the early 1900s automobiles came to Orlando, and of course, there just had to be a parade of these treasured machines as they toured the city. The date was June 21, 1911, and the location was Orange Avenue, pictured here in a view looking north from Pine Street. The parade caused quite a stir, and residents stopped to look at the passing automobiles. The front left car appears to be a locomobile, a well-known, sports-racing car. Most of these automobiles in 1911 were steered from the right rather than the left side that is today's standard in the United States.

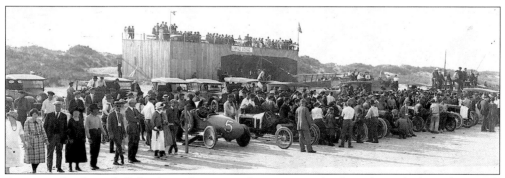

Auto parades through Orlando to the county fair were popular from the early days, along with auto racing, which drew crowds of people who had fallen in love with these new machines. Here, fans pore over every detail of the autos entered in the day's race.

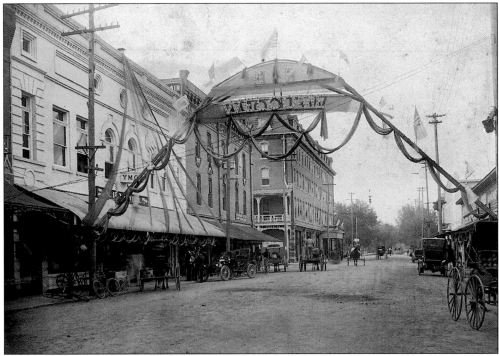

In mid-winter, Orlando was often decked out to welcome visitors. This event was probably the Orange County Fair held each February. There were races at the fairgrounds; cars were decorated with flowers and other ornaments and paraded for all to judge. In 1911 the automobile voted first place was owned by a Miss Wright.

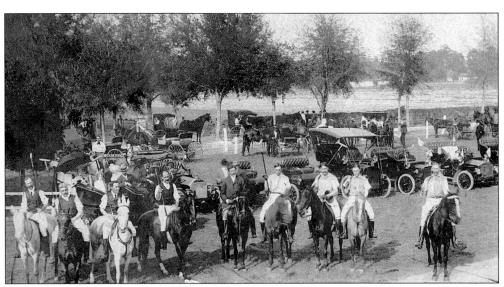

The Orlando Polo Club was organized in 1890 with more than 100 members. Some are seen here in this early 1900s view of Hopper Field where they practiced and played. Duncan Pell, second from the left, was part of Orlando's four-man team, whose official team colors were red and green. The opposing team this day was from Camden, South Carolina.

A more modern-day public entertainment, an art fair is pictured on this postcard intended to be mailed home to envious friends. This is a spring art fair in progress in Winter Park. Some artists visit fairs like this one year-round, following the warm weather.

T.P. Robinson turned many of his Orange County photographs into postcards. This is one such card featuring Roman candles on Lake Lucerne on March 18, 1909. The candles were shot off in sham battles for nighttime entertainment. Water, warm breezes, and a light show, too—what a fine way to spend a spring evening.

101

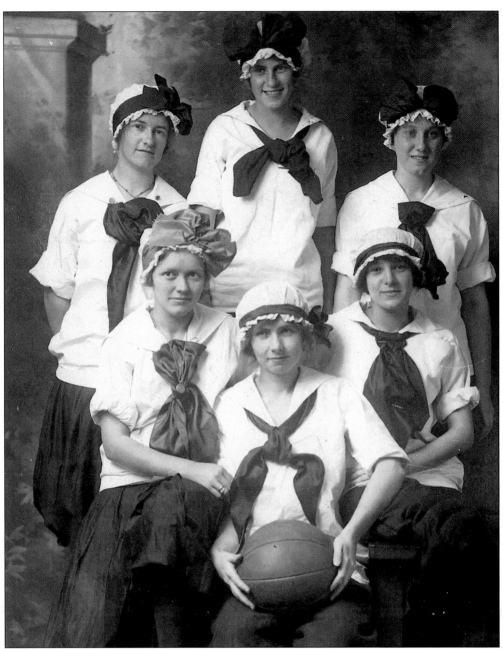

Orlando High School and Rollins College furnished most of the spectator sports entertainment for residents and visitors. After a day of golf, tennis, or bowling, one could watch girls basketball at the high school. The members of the 1914 team seen here are, from left to right, (front row) Doycek Matthews, Bessie Quigg, and Marian Smith; (back row) Arline May Matthews, Elbeth Mulholland, and Kathy Padge. Basketball was a relatively new sport in 1914 after having been invented by James Naismith in December 1891 to relieve the boredom of students in gymnasium classes. It wasn't until 1893 that women's rules were written by Clara Baer. In the early years the number of players varied with the size of the playing surface available and girls only played a half-court game, each playing as either forward or guard.

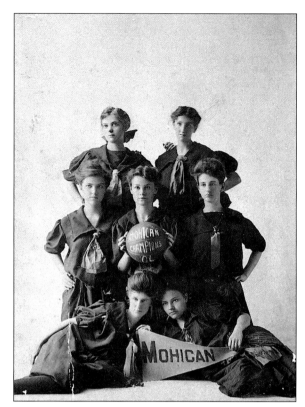

Pictured here are two champion basketball teams. The 1906 Mohicans, above, are from Rollins College and look very confident about their victory. The 1911 Orlando High School state champions, below, have that same look of determination. When these girls were playing, the teams still used a peach basket. It wasn't until 1912 that the basket was replaced with a ring and a net with a hole in the bottom.

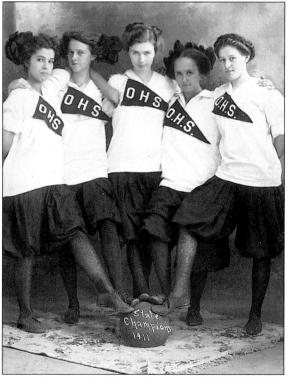

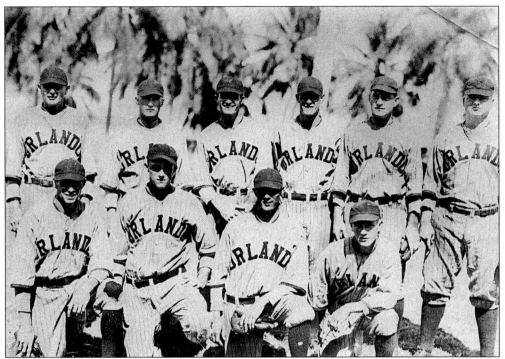

Baseball is a much older game than basketball, and it is said to have evolved from children's games such as "rounders" or "one old cat" in 1839. Pictured here is an Orlando men's baseball team getting ready to play ball right after the team picture is taken. Unfortunately, no one in the photograph is identified.

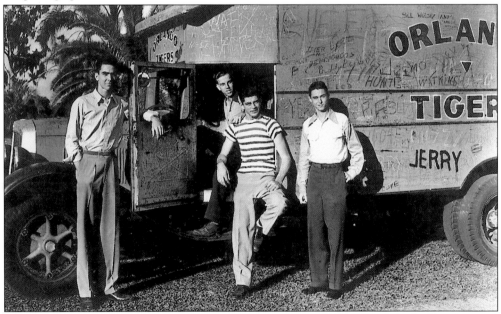

The Orlando Tigers were the pride of Orlando High School. Their truck looks like the team message board with all the names scratched in and painted on it. It is uncertain what sport these young men played, but it is likely to have been basketball.

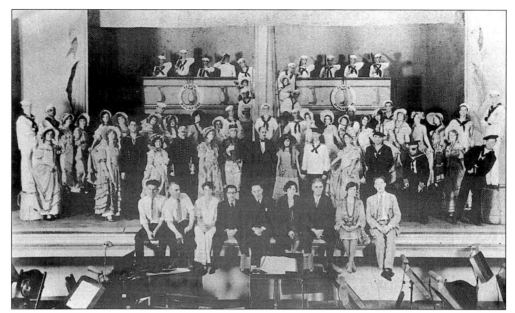

When Orange County residents and visitors weren't listening to music, watching a parade or a sporting event, there was usually a play in rehearsal or one to be seen. Pictured here is the cast and crew of *H.M.S. Pinafore*, which was presented in February 1930. Gilbert and Sullivan plays were longtime favorites of Orlando players, especially as produced by the Mendelssohn Club, a prominent social club in the city.

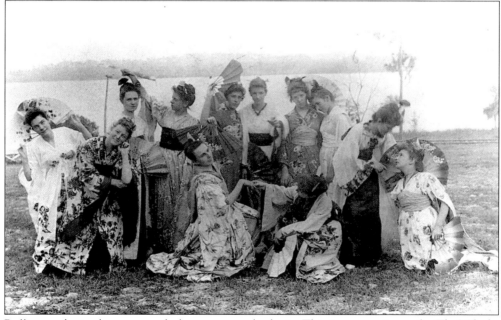

Rollins students also presented plays on a regular basis. This is a cast picture for *The Mikado*, Gilbert and Sullivan's most popular opera. Gilbert and Sullivan worked together from 1871 until 1896, and *The Mikado* was first performed in 1885.

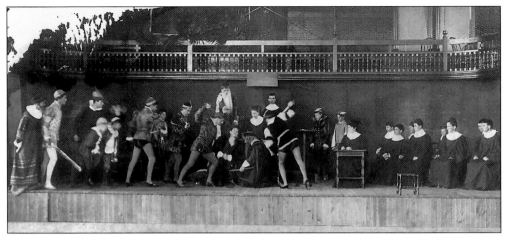

Shakespeare was another popular playwright of the era. Seen here is the cast of characters from *The Merchant of Venice* as performed in April 1903 in the Orlando Opera House. Orlando was no doubt on the circuit of touring companies of the day.

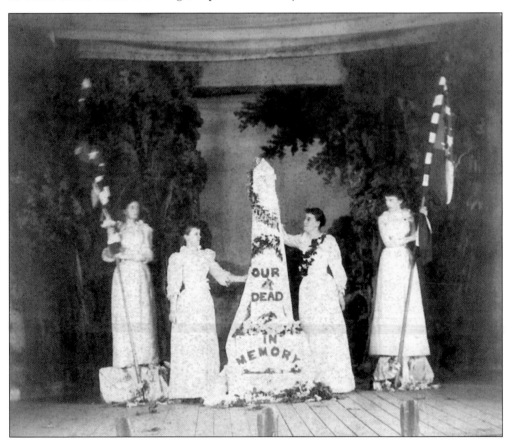

This theatrical performance was given much earlier than the one in the previous image, probably in the late 1800s. H.A. Abercromby photographed this cast group, only two of whom are identified. On either side of the memorial are Eula Smith (left) and Hallie Fernandez (right).

Six

FLORIDA'S AIR CAPITAL

Previous chapters have looked at how settlers, businessmen, and tourists traveled to Orange County by horse, boat, and car. Now we take a look at how aviation came to the county. Among those who visited or wintered in Orange County were wealthy men who wanted all the latest gadgets. Of course they would be fascinated with the airplane, both as a toy and as a faster means of transportation!

Before World War I most Americans saw their first airplanes at local celebrations or county fairs. Many pilots who were trained for World War I continued to fly surplus Curtiss JNs, called "jennies," taking their planes all over the country to show what they could do. This was called barnstorming.

Ed Nilson of Orlando, known as "the father of Orlando aviation," was the one man who advised others on aviation, promoting and commercializing the industry in the process. Nilson became Orlando's first director of aviation, and in 1934, he moved to the Civil Aeronautics Administration.

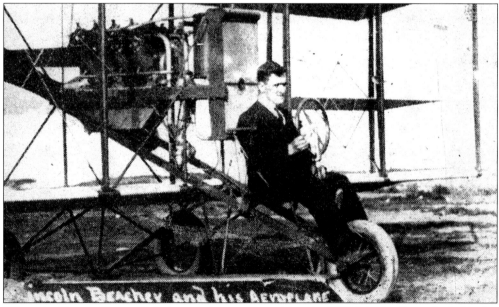

When the Orange County Fair Association was organizing the 1910 fair, the first to be held after the 1895 freeze, members wanted an attraction that would draw a huge crowd. They offered a $1,500 prize to the first aviator who could go up and stay up for at least five minutes. Lincoln Beachey, a well-known daredevil, not only went up and kept his plane in the air but did it every day of the fair! Pictured here, he was the first man to fly from Florida soil.

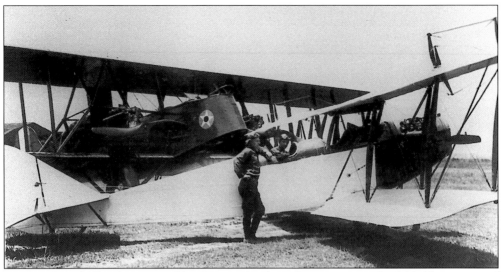

In 1922, E.C. (Ed) Nilson moved his Bartow Airplane Corporation to Buck Field, just west of Orlando. He had been offering aerial photography and mapping services, advertising, passenger service, and flying instruction since 1919. Nilson renamed the company Orlando Airlines, Inc. and added aviation advisory services to his business. He built a hangar that would hold six airplanes at the field. By 1927 Nilson proclaimed Orlando Airlines's five-plane fleet to be the second largest airline in Florida.

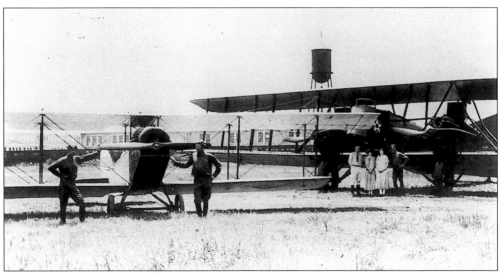

Orlando Airlines offered service from Orlando to major Florida cities in addition to flying twice-a-month payrolls from Orlando to Fuller's earth mines in North Central Florida. Four pilots were employed by 1922: Livingston Stacey, Leon Sherrick, Jimmy Johnson, and Huzz Mueller (who would become a partner in 1924).

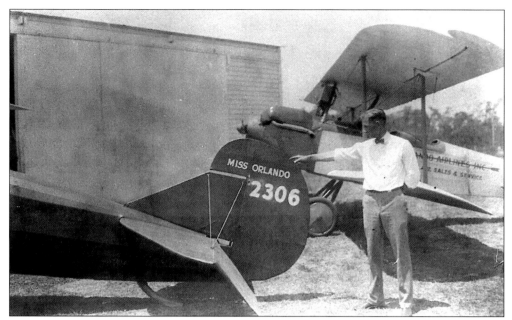

Ever the promoter, Nilson took his *Miss Orlando* to the 1927 national Junior Chamber of Commerce convention in Omaha. *Miss Orlando* was an open cockpit Beech Travelair. Upon his return, the Jaycees began their campaign for a city airport. The City had purchased property on the north and west sides of Lake Underhill from Dr. Phillips to protect the city's drinking water supply. The Jaycees thought that was just the place for an air field.

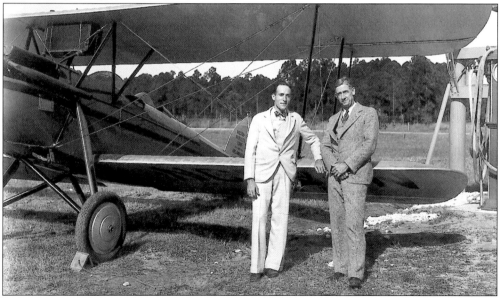

In 1924 Nilson and Ernest (Huzz) Mueller became partners in the aviation business and changed the name of the company to Nilson-Mueller Corporation. This business was expanded to nine distributorships of airplanes and parts in the state of Florida. The company was the first to place a full-page ad in an aviation magazine, and they were the first distributor to take delivery on a carload shipment of airplanes. The company also used automobile showrooms all over the state to exhibit their airplanes.

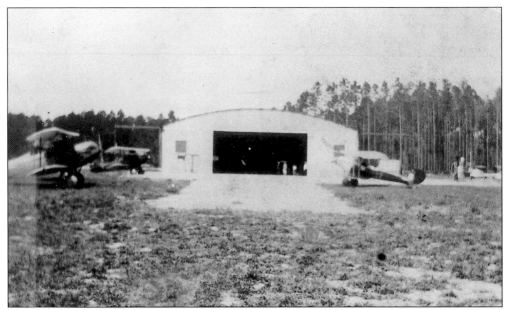

In 1929 the Orlando Municipal Airport was a sod field measuring about 2,600 feet north to south and over 3,200 feet long next to Lake Underhill. Pictured is the lone hangar with two Waco 9s owned by Nilson-Mueller on the left and an American Eagle owned by Jack Keen on the right. Nilson-Mueller moved their operations and their steel hangar from Buck Field to the Municipal Airport when it opened.

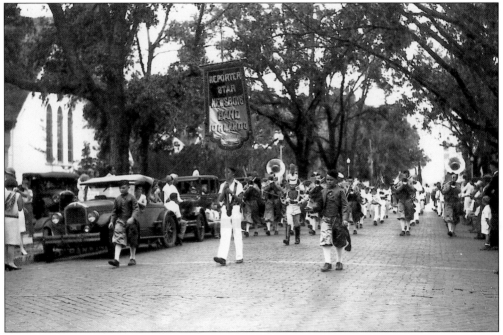

Orlando loves a parade. It seems that the whole town turned out for this one on October 4, 1928 held as part of the opening of the Orlando Municipal Airport. In addition to buying the land, the city set a budget of $2,500 for the preparation and upkeep of the facility. Additional funds for the airport were raised by the sale of fruit from the old grove.

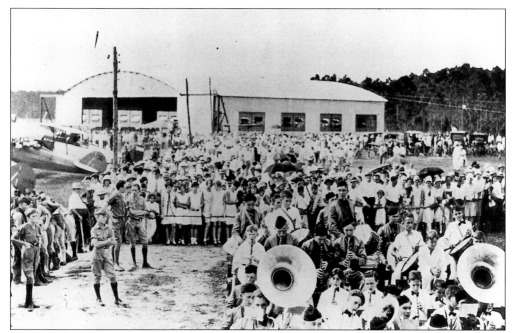

Almost 40,000 people showed up for the two-day opening ceremonies, but in this photograph, the band gets all the attention. Earlier, Nilson and O. Forest McGill flew over towns of Central Florida, dropping thousands of invitations to the event that told all about the elaborate program that was being planned.

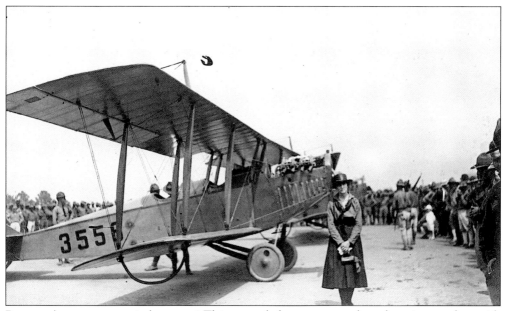

But people came to see airplanes too! This young lady was eager to have her picture taken with one of the planes that flew in for the festivities and was probably hoping for a ride as well. The whole town worked to make this opening a success. Restaurants offered special menus and all the local hotels were filled for the celebration.

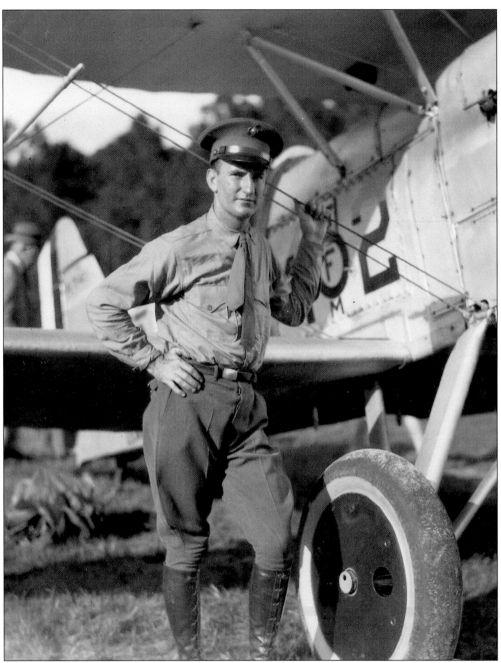

Aviators enjoyed flying in for airport openings and did so whenever the opportunity presented itself. Invitations were sent to prominent aviation enthusiasts to attend openings of new airports of which there were quite a few in the late 1920s and early 1930s. The aviators enjoyed showing what their machines could do in the air. The pilots were also very generous and took many people for their first, and sometimes only, ride in an airplane. Several days after the October 4 opening, a representative of Pan American Airways arrived to inspect the airport and found it adequate to accommodate the airline's planes. Orlando was to be a stopping point for Pan Am in its services to Cuba and Puerto Rico.

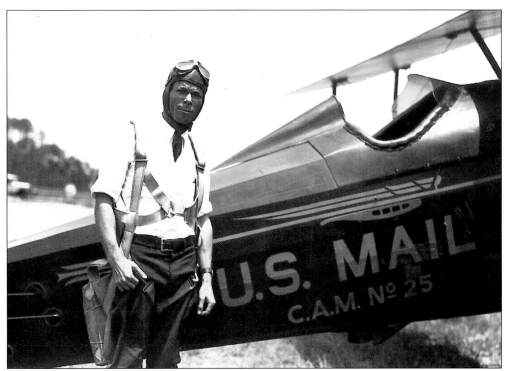

The first U.S. airmail service was begun at College Park Airfield in Maryland in 1918. On December 1, 1928, Pitcairn Aviation established airmail service between Atlanta, Jacksonville, and Miami. On March 1, 1929, Orlando, Tampa, and Daytona Beach were added to their routes.

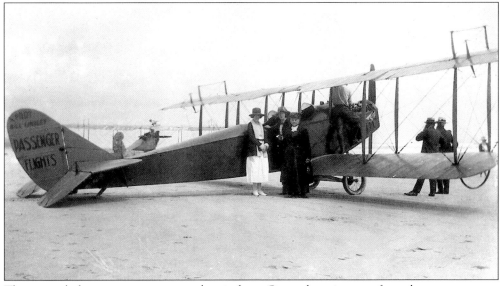

These people have come out to see the airplane. Since there is space for only one passenger, they could not all have arrived by air. They are not dressed for air travel either. Going out to the airport was a popular Sunday diversion in the early days of aviation in Orlando.

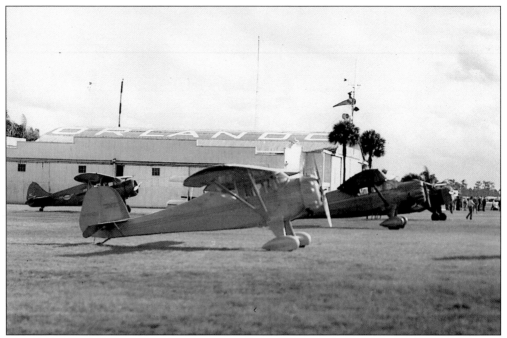

Maj. A.B. McMullen of Tampa was appointed the first aviation director of the Florida State Road Department in 1933. When he surveyed the state's airports, he discovered that Florida had 69 usable airstrips and five military airfields. Ed Nilson of Orlando was a tireless promoter of air travel, and in 1933, he proclaimed Orlando the "Air Capital of Florida."

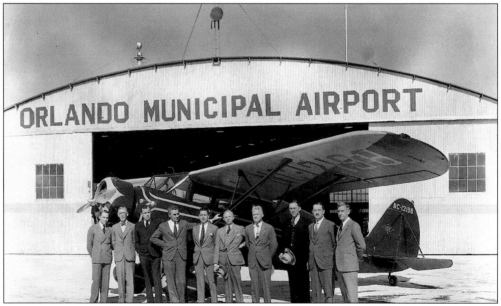

McMullen's survey proved to very helpful, and Florida was the first state to publish an aviation map and airport directory. The directory listed Orlando with a municipal airport of 120 acres with a hangar. The survey made it possible to participate immediately when the federal government began offering their many "alphabet" programs such as WPA. This 1933 reception committee was a common sight for visitors who flew in and were always welcome.

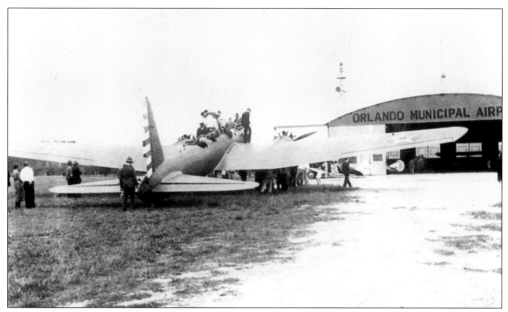

January 1934 saw the beginning of Orlando's annual air parties. Ed Nilson started the Dougherty Sportsman Pilot Cruising Race, which began in Orlando and ended in Miami in time for everyone to see the All-American Air Maneuvers. In the first year, 93 airplanes and two to four times that number of people came for the event. Here, people examine the first bomber to fly into Orlando Municipal Airport.

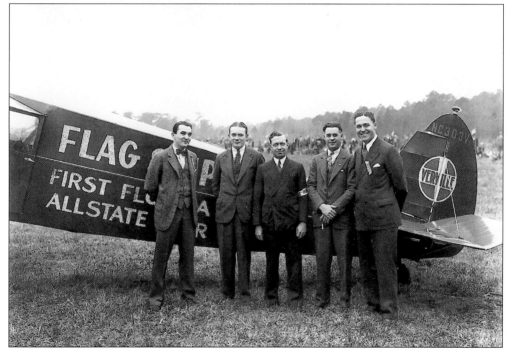

Pictured here is the flagship for first Florida Allstate tour held in 1929. This tour was a one-day meet run by the Jaycees who were proud of the results of their efforts to open a public airport in Orlando. They continued to promote the city and aviation far and wide.

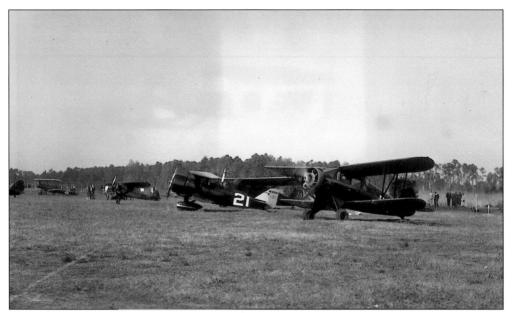

Weather was bad for the second race year in 1935 but that didn't stop aviation spectators from coming to see it. The contestants vied for a $500 silver trophy, the prize for flying the fastest time from Savannah, Georgia, to Orlando. By January 8, 22 planes had completed the race.

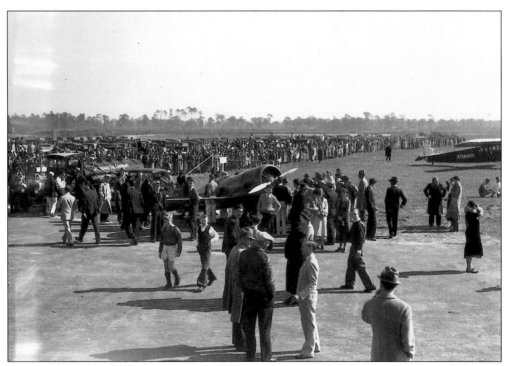

It was said that hundreds of sportsmen pilots and their guests flew down the fog-bound Atlantic seaboard to attend the races in 1935. Long-lasting friendships were formed among these pilots. Some eventually bought houses in Orange County.

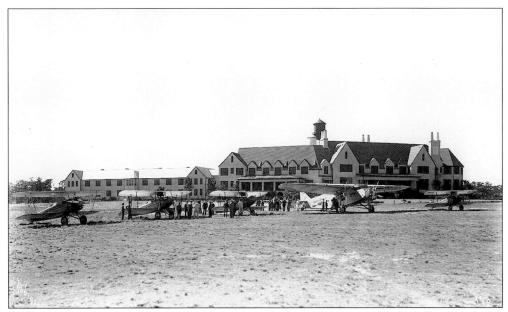

Mt. Plymouth Aviation Country Club was a popular destination in 1935 when the formal race program was abandoned due to the weather. A WPA landing strip had been built on the golf course at Mt. Plymouth on which the planes could land. This was a popular gathering place for the aviators flying on the Florida Air Show.

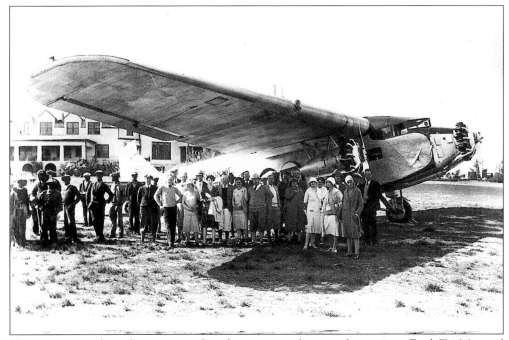

Here, a group of revelers get together for a group photo under a giant Ford Tri-Motored Monoplane at Mt. Plymouth. The annual air parties ran for six years with much success because of Orlando's reputation of hospitality and good will towards the visitors.

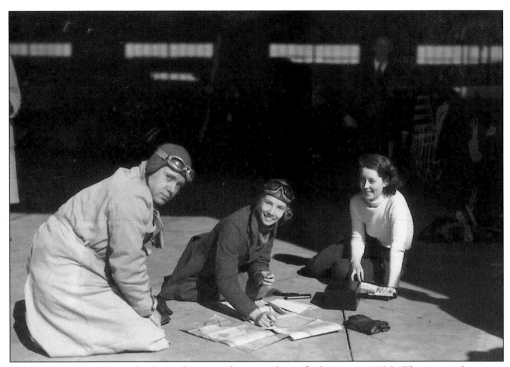

These young people study their charts and get ready to fly home in 1935. The party that year was remembered not only for the bad weather but also for the Army Air Corps and the Marine pilots who participated in the display. Over 300 military planes flew during the event.

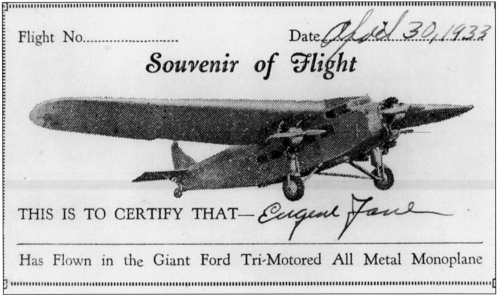

Flight No. Date *April 30, 1933*

Souvenir of Flight

THIS IS TO CERTIFY THAT— *Eugene Jane*

Has Flown in the Giant Ford Tri-Motored All Metal Monoplane

With the beginning of commercial air travel, many people took their first rides in large planes. Those passengers who traveled in the Giant Ford Tri-Motored All Metal Monoplane received this particular certificate much as today's young passengers receive their wings. The "Tin Goose," as it was known, was noisy, vibrated badly, and was not climate controlled.

118

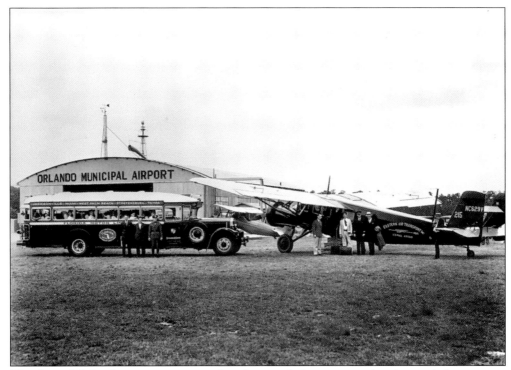

The City of Orlando was one municipality that regularly maintained and upgraded its airport. Eastern Air Transport (later named Eastern Airlines) began regular flights into Orlando in 1931. The regional bus system made the air terminal one of its stops. This made the smaller towns without air service accessible to air passengers.

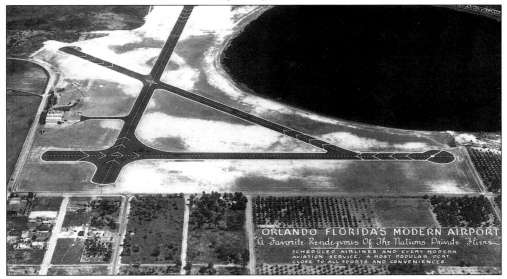

This aerial photograph was taken on the tenth anniversary of the airport. Orlando had participated in the WPA program by making field improvements, and paving projects and the installation of night lighting facilities were begun in the 1930s. Notice that by 1938 there were three runways measuring approximately 2,500 feet in length and a paved approach to the hangar.

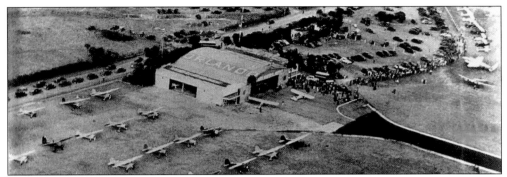

Traffic jams are nothing new. This 1939 photo of the airport shows the hangar and parking facilities for both cars and airplanes. We don't know what this particular event was, but it must have been some sort of public reception for an important arrival. The airport renovations included an expansion of hangar space, which rented for $5 per month for a light plane. In 1922 there were only 1,200 non-military planes in the United States. By 1930 there were 3,095 private planes. According to the 1930 *National Air Races Directory*, aviation had established itself as an essential part of the commerce of nations and become indispensable to the mail service.

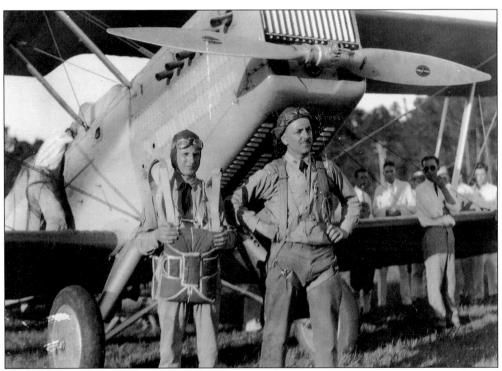

These pilots are participants in an air show at Herndon Field. The Orlando Municipal Airport was renamed Herndon Field in honor of A.B. (Pat) Herndon, a city engineer, in March 1961. In July 1982 it was renamed Orlando Executive Airport.

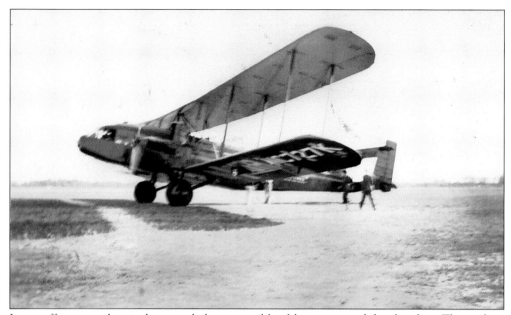

In an effort to make airplanes as light as possible, fabric was used for the skin. The earliest plane had wooden skeletons, and later ones were made of lightweight aluminum. The fabric was a strong cotton rug cloth and was covered with a "dope" composed of lacquer mixed with powdered aluminum. The drying of the dope shrank the fabric, making it tight and resistant to sun rot. After the fabric was dry, it was sanded and colors were added.

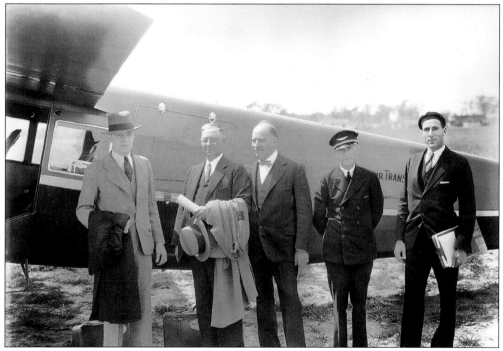

The men on the left are off on a trip. The pilot stands to the right and the man on the far right has his hat on backwards for a reason—the person who spun the propeller to start the engine wore his hat backwards so that the wind from the propeller would not blow it off.

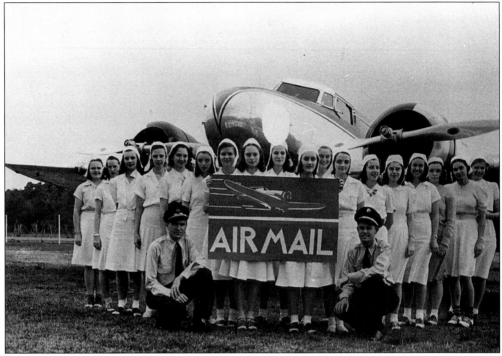

Air education was always stressed by the Aviation Division of the State Road Department. Florida's first aviation course was added to the curriculum of the Orange County Vocational School in 1938. Rollins College, in cooperation with the Vocational School and the Orlando Air School, became one of the first federally approved agencies in the South to train pilots under the civilian pilot training program in 1939. Orlando High School students (pictured here) formed clubs to train in aviation.

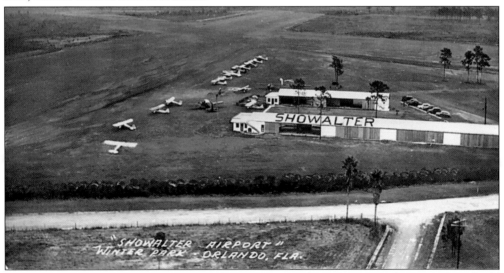

Howard and Sandy Showalter and Buck Rogers moved to Winter Park in 1945 to build Showalter Airpark. Their interests were many. The Showalters and Rogers sold three-wheeled Motorettes and held a distributorship for the piper cub in addition to giving flying lessons and operating a "Sky-Cab" passenger and freight service.

122

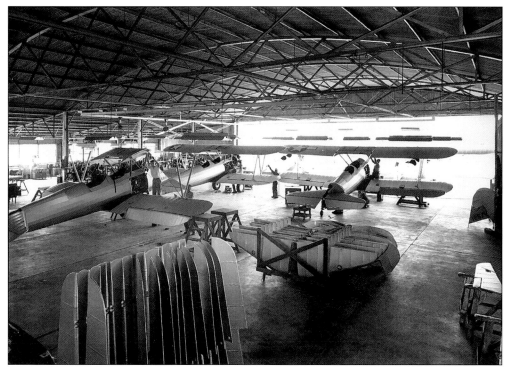

Monocoupe opened an assembly plant next to the Orlando Municipal Airport in 1940. Parts were shipped to Orlando and assembled in the hangar shown above. The star and bar insignia on the left upper wing indicates that the plane was manufactured for World War II use. This plant closed in 1947.

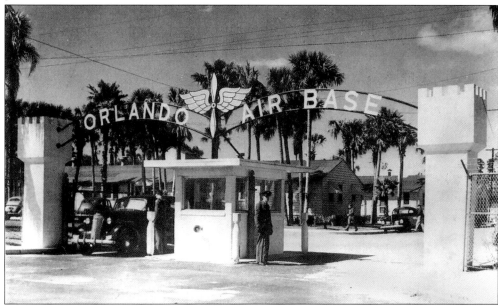

Orlando leaders were aggressive in seeking a military base for their airport. They offered the Army Air Corps 740 acres of land for use as the Orlando Air Base. The federal government made all the needed improvements.

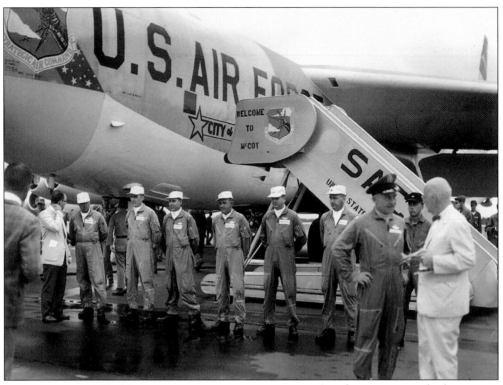

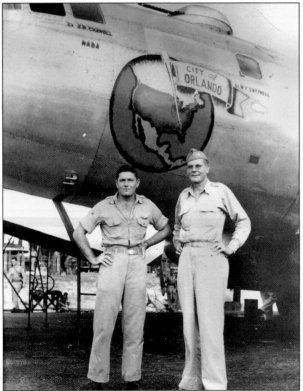

Another airport was built at Pine Castle in the 1940s for commercial use while the army used the Municipal Airport. Pine Castle was reopened as a military field in 1952, and in 1954 it was transferred from a training to a bomber command. Mayor Bob Carr is shown here inspecting the Strategic Air Command bomber at McCoy Air Force Base while the pilots stand by.

Col. Michael N.W. McCoy was killed during practice in 1957. Pine Castle was renamed McCoy Air Force Base in his honor in 1958. After deactivation, this airport became Orlando International Airport. This bomber stationed at McCoy was named the *City of Orlando*.

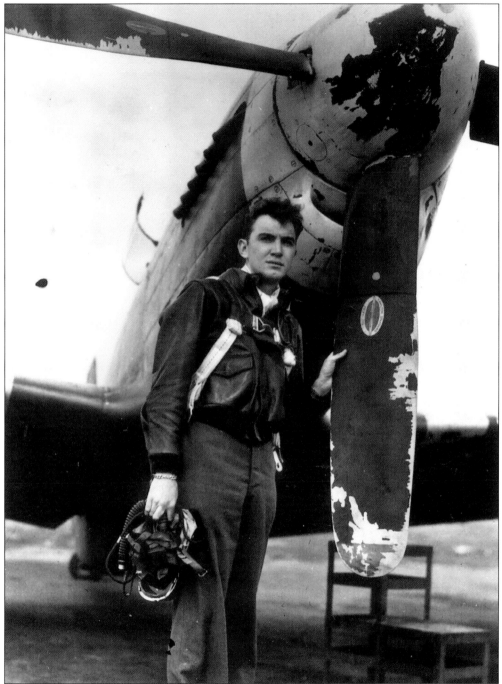

First Lieutenant James N. McElroy joined the 355th Fighter Group of the Eighth Air Force in England in March 1944 where he flew two tours of combat that included 99 missions. He became an "Ace" by shooting down five enemy aircraft in aerial combat. He also destroyed six more enemy aircraft while strafing enemy airfields. His other targets included trains, barges, and other vehicles. McElroy' flew a P-51 B and a P-51 D, both of which he named *Big Stoop*. He rotated back to the United States in March 1945, just before the end of the war.

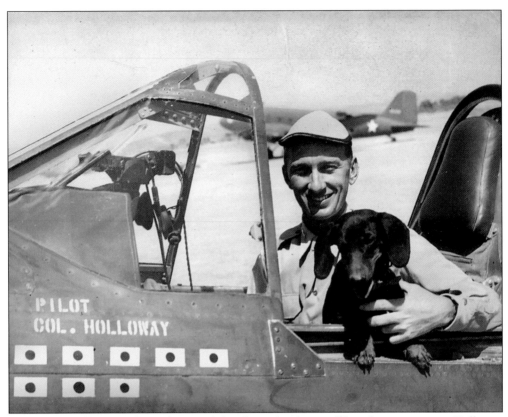

Col. Bruce Holloway is shown here with his dog as he shows off his plane to visitors. Holloway was known to have flown every plane that the Air Force let him near. When he retired in 1972, Holloway was a four-star Air Force general.

The Civil Air Patrol was organized on December 1, 1941, and the members became the "Minutemen" of World War II. Members volunteered their time and talents to patrol the shorelines as well as perform sea search and rescue missions. This 1945 photo shows Orange County's Civil Air Patrol members.

INDEX